TRAVELS THROUGH THE WIZARDING WORLD AN OFFICIAL COLORING BOOK

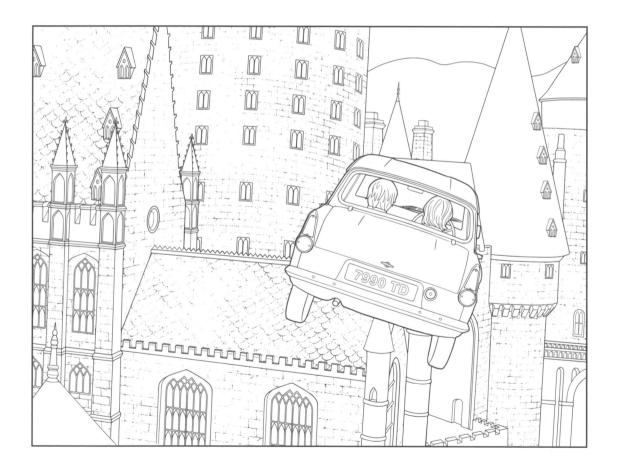

SAN RAFAEL • LOS ANGELES • LONDON

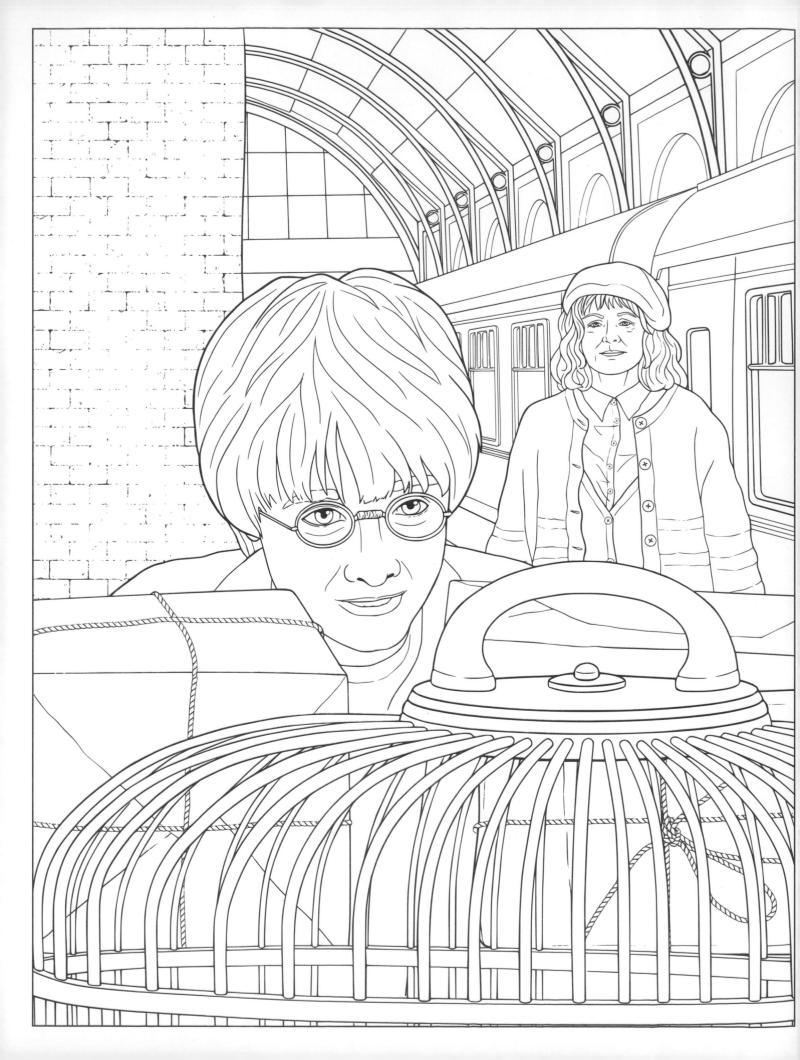

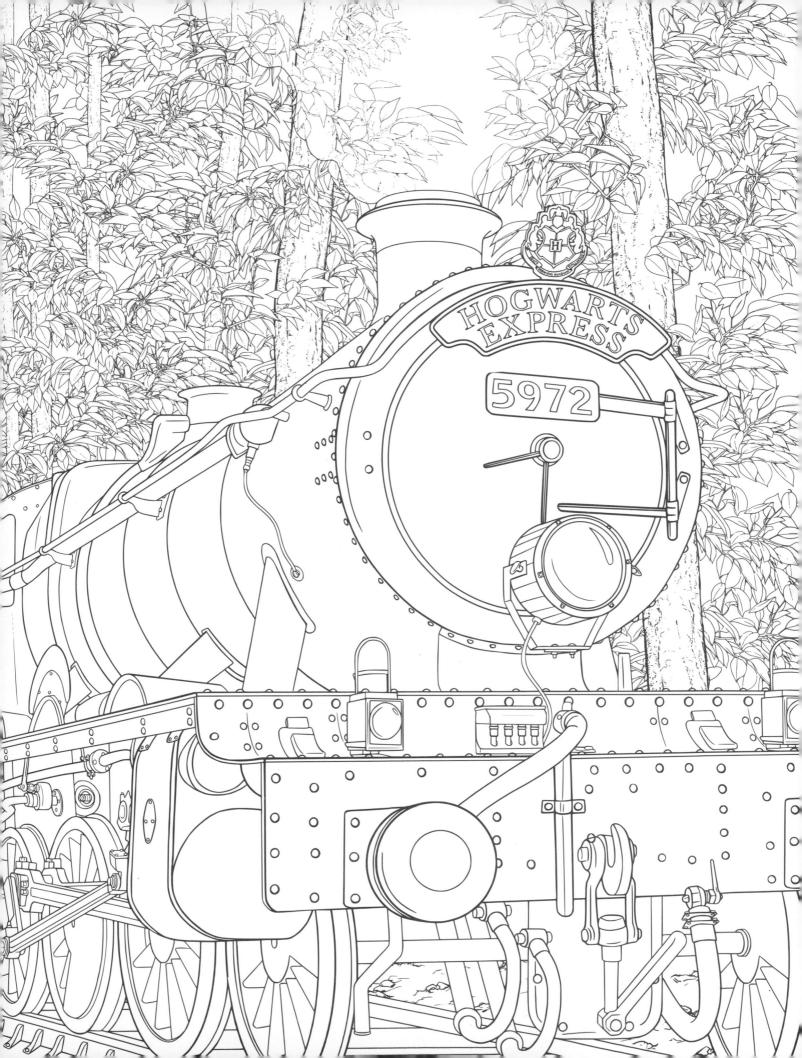

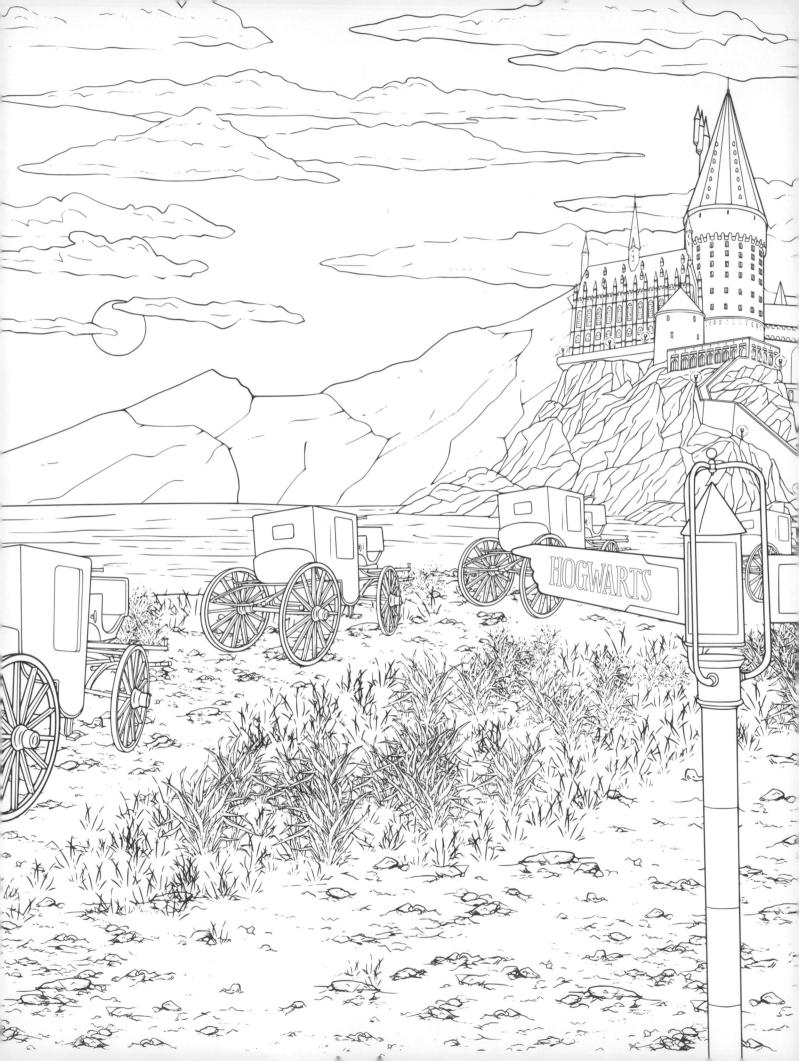

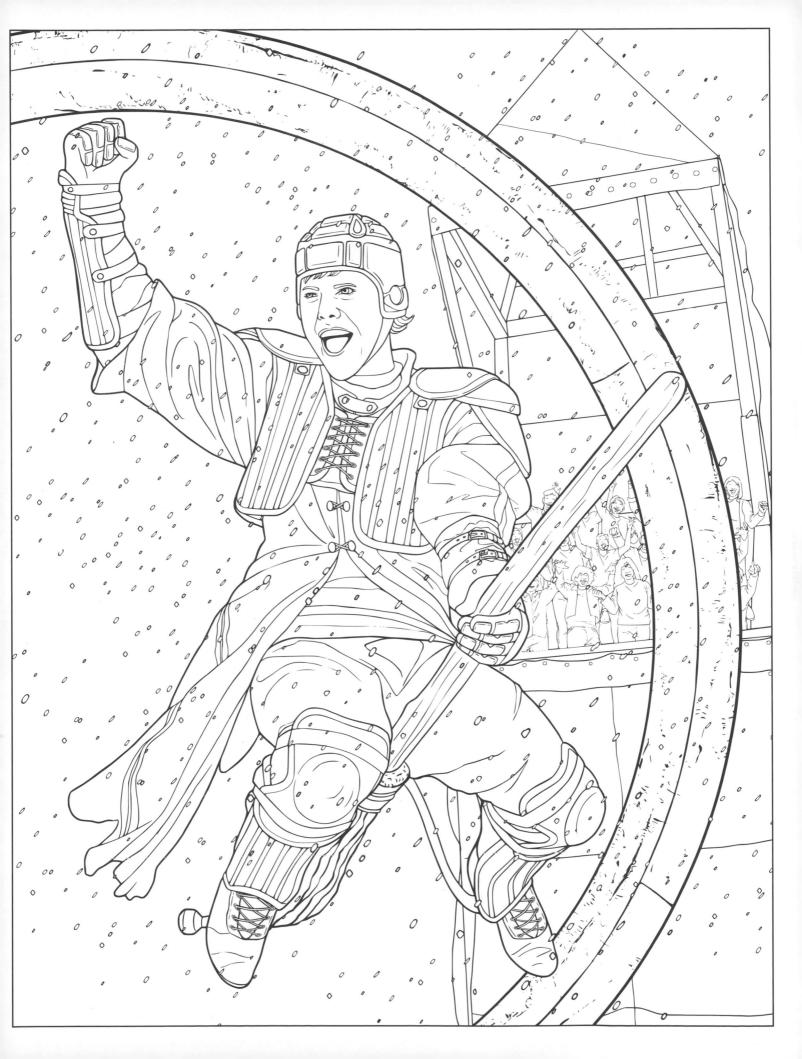

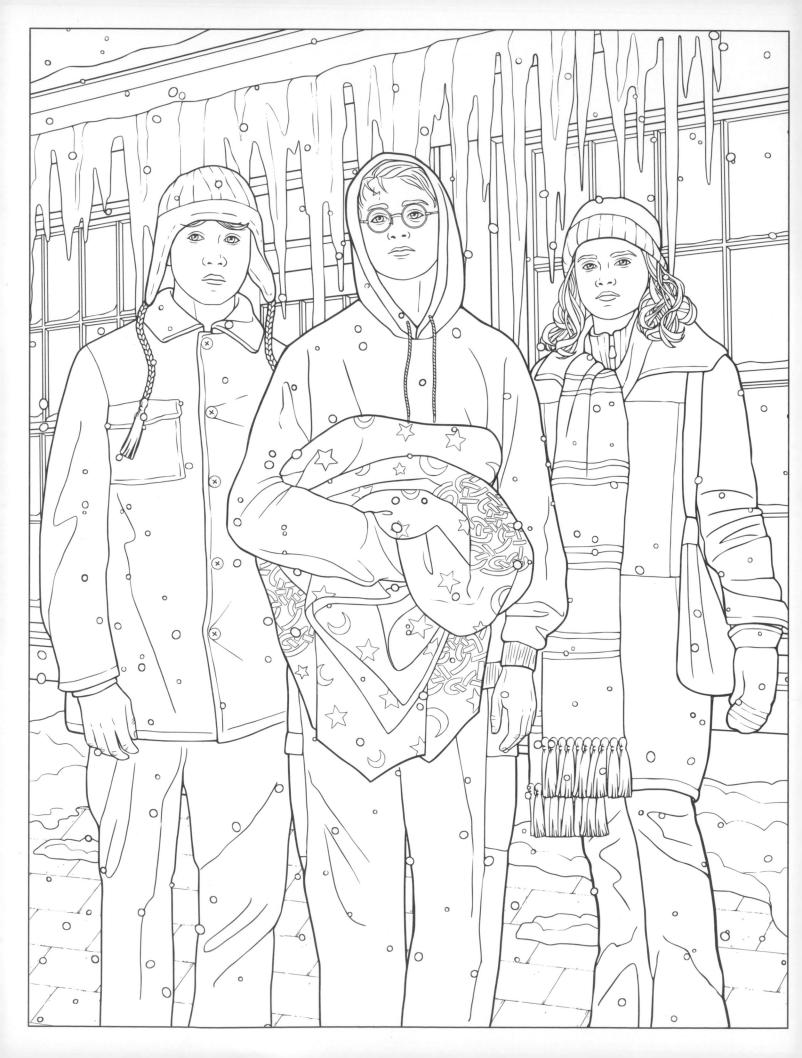

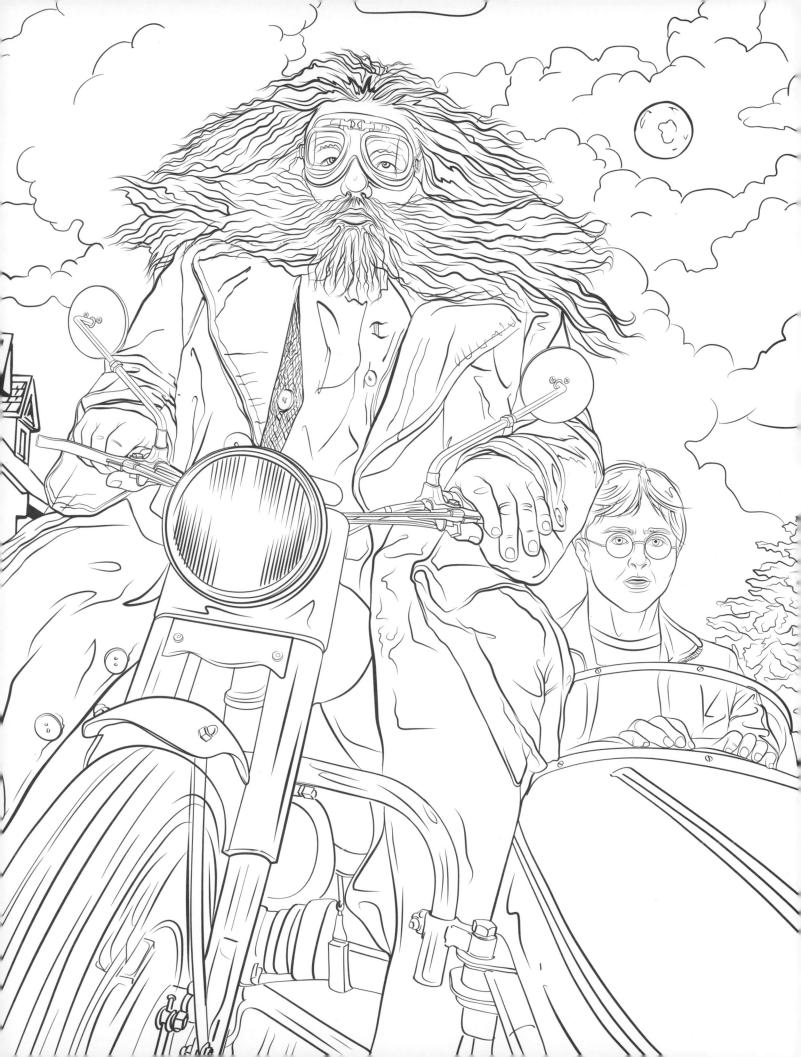

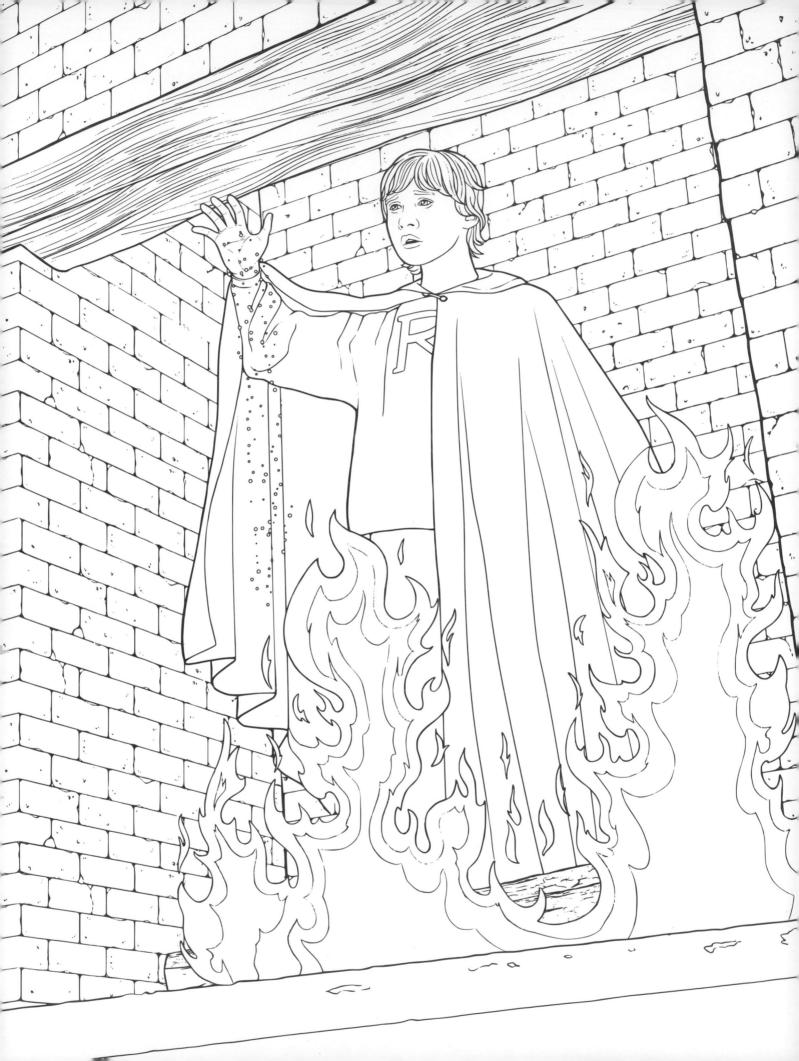

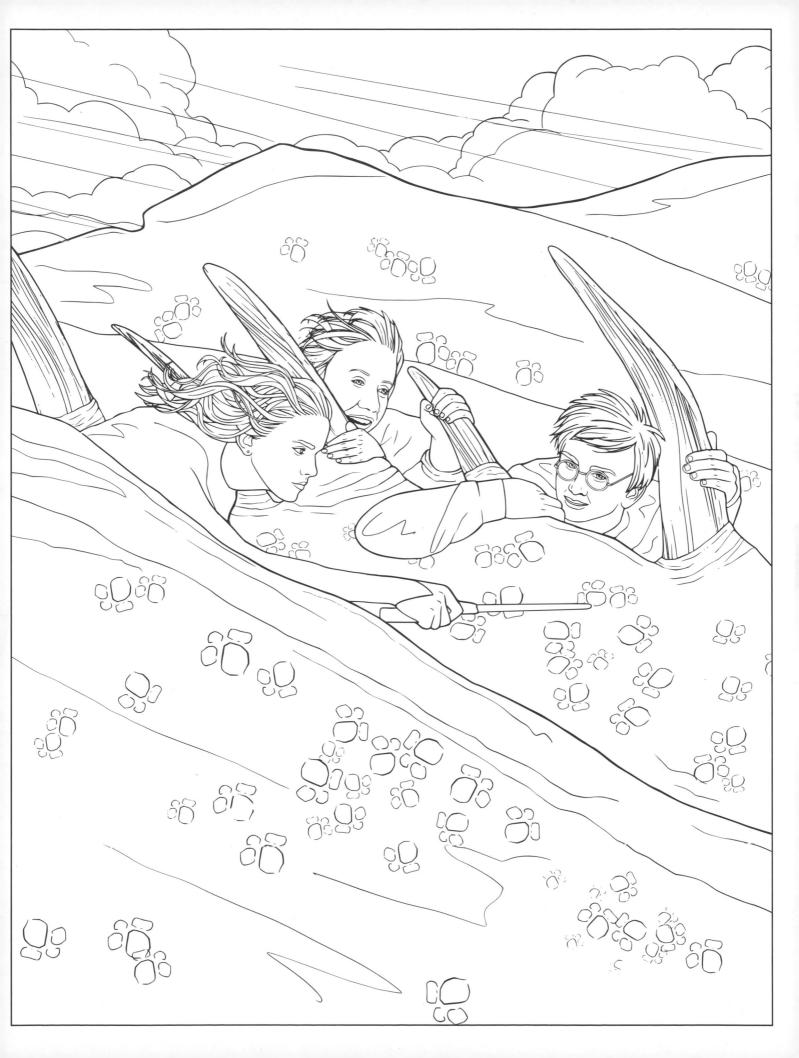

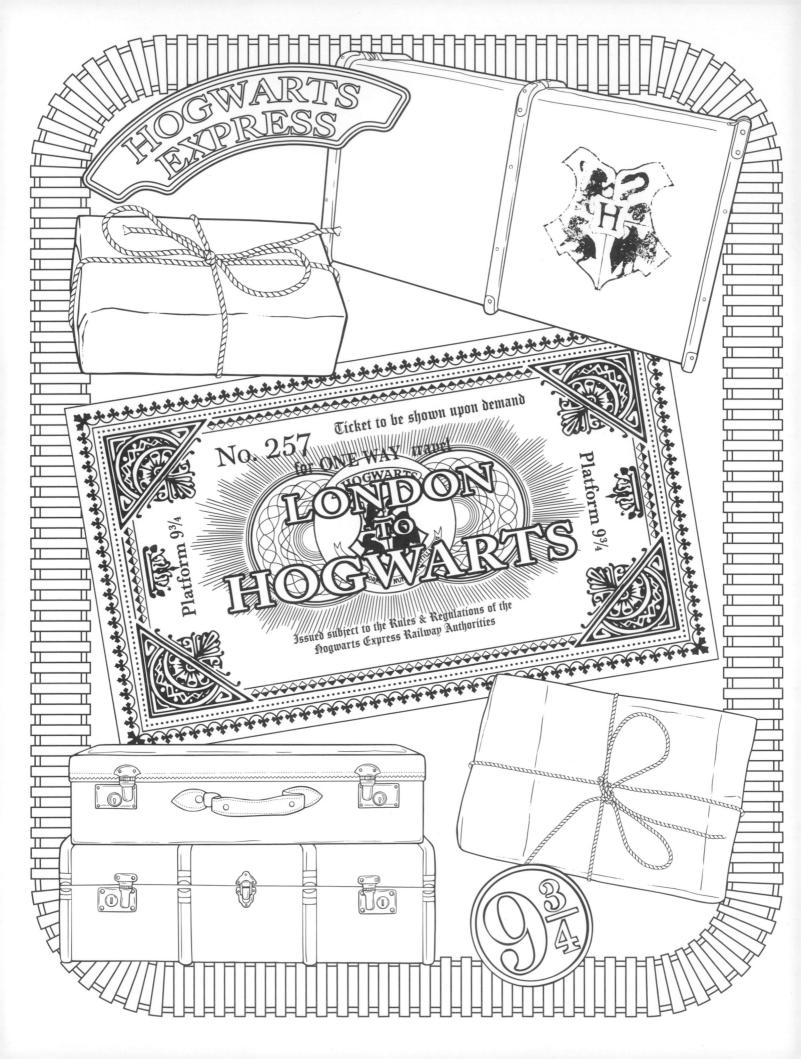

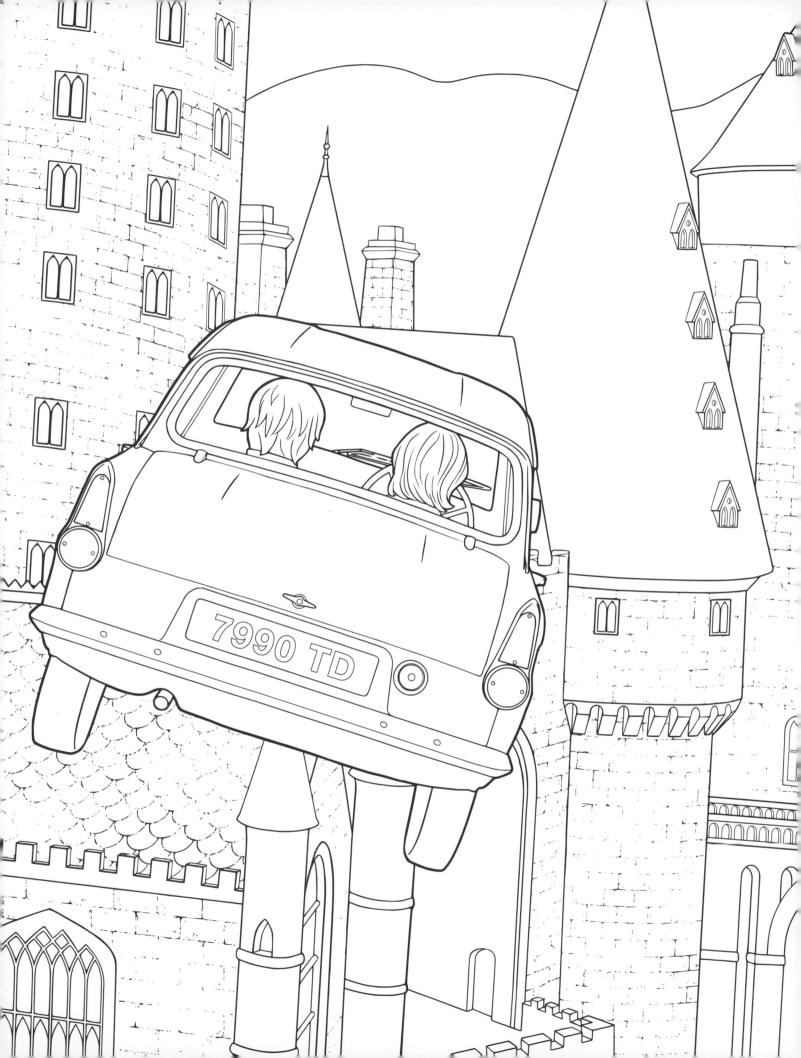

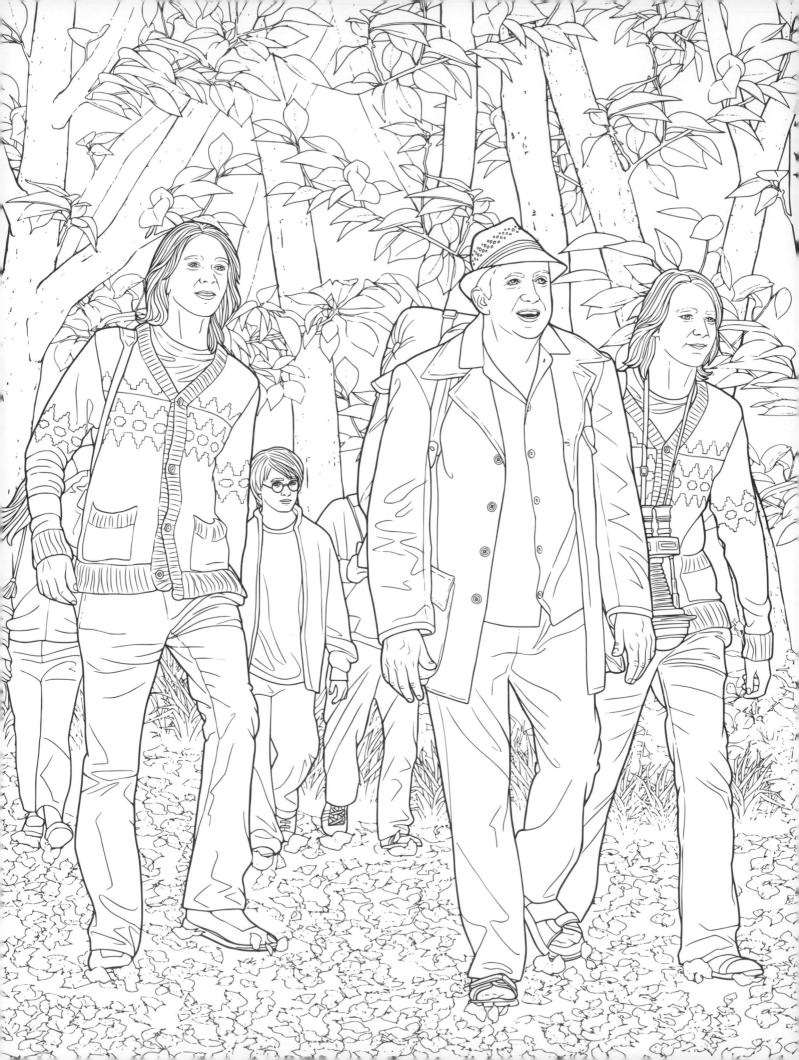

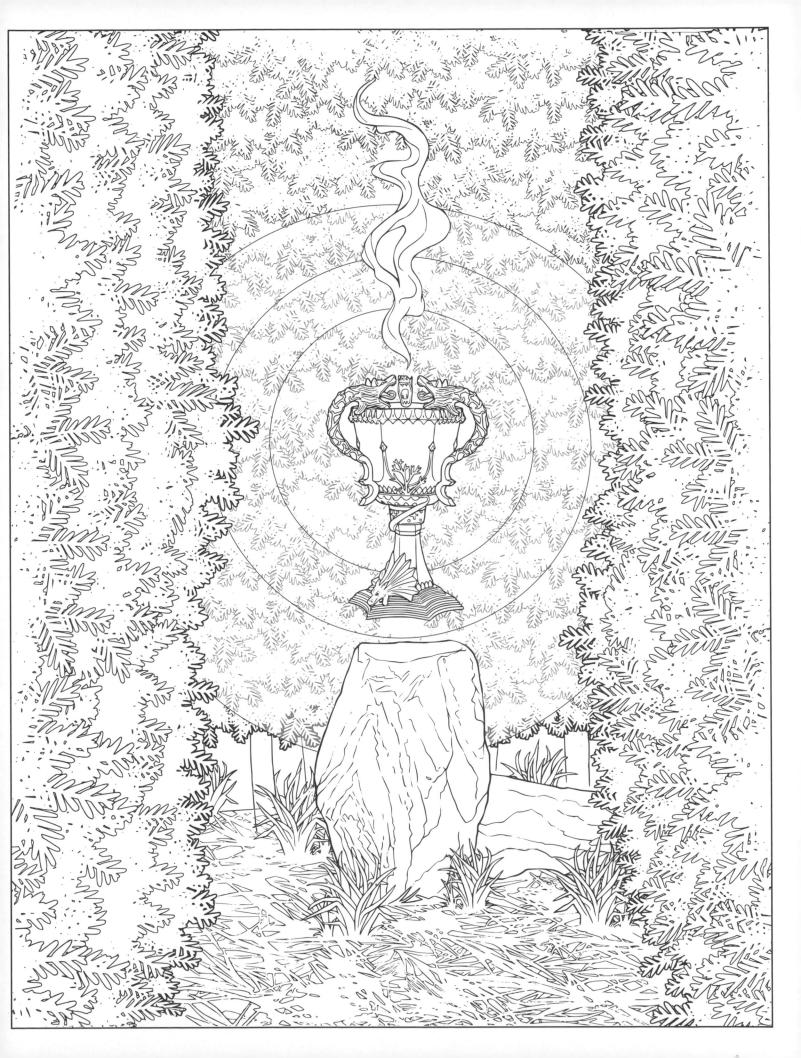

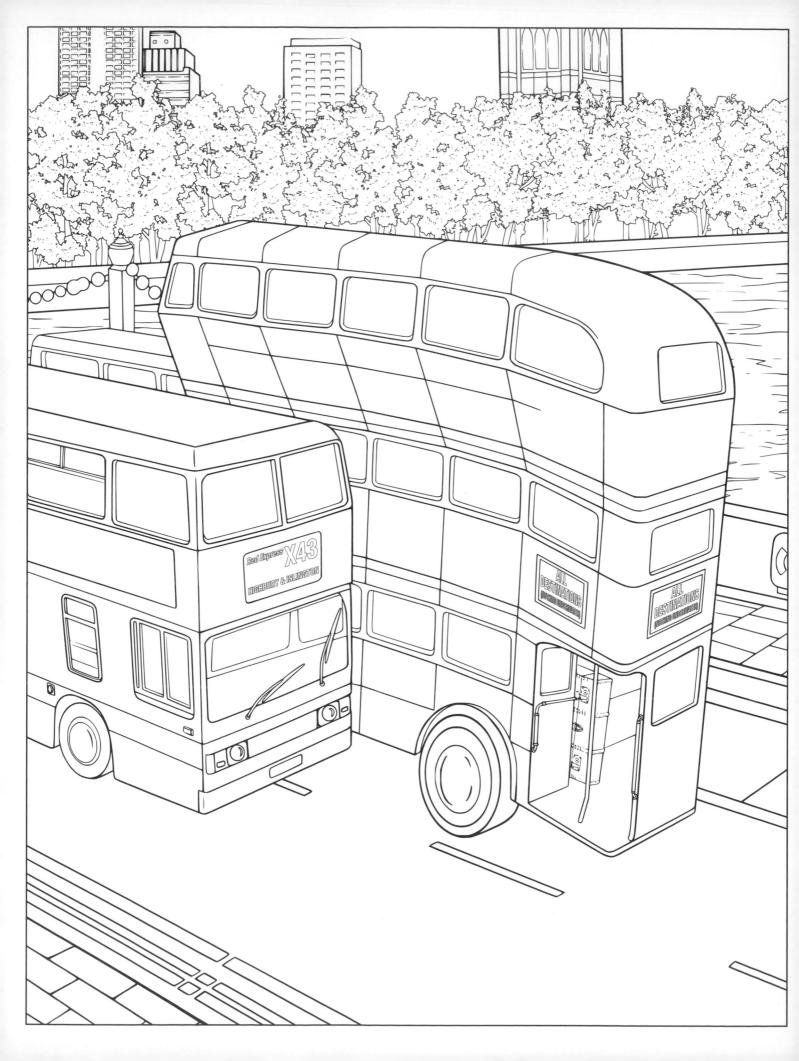

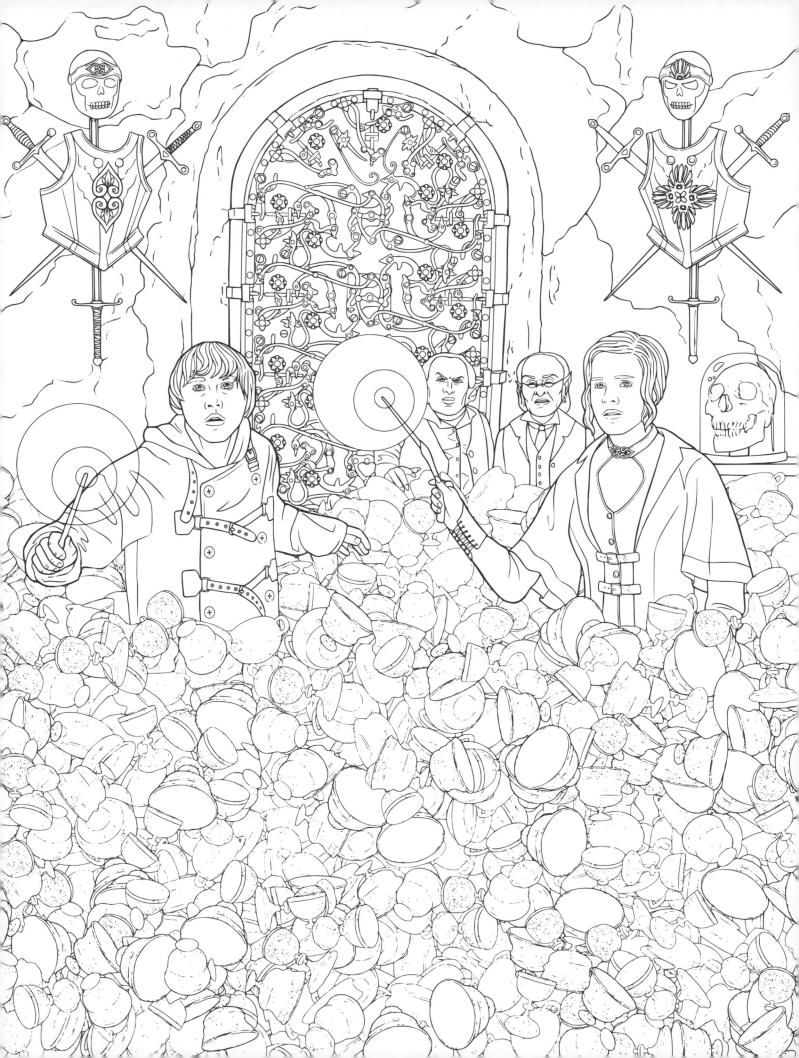

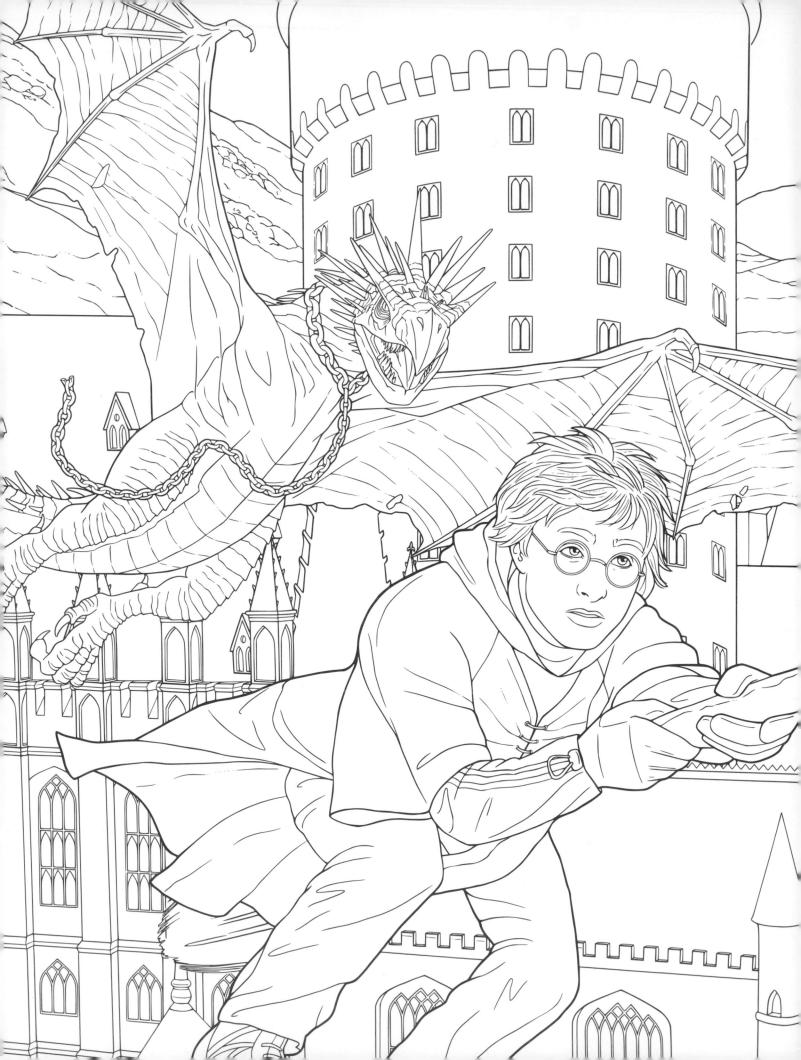

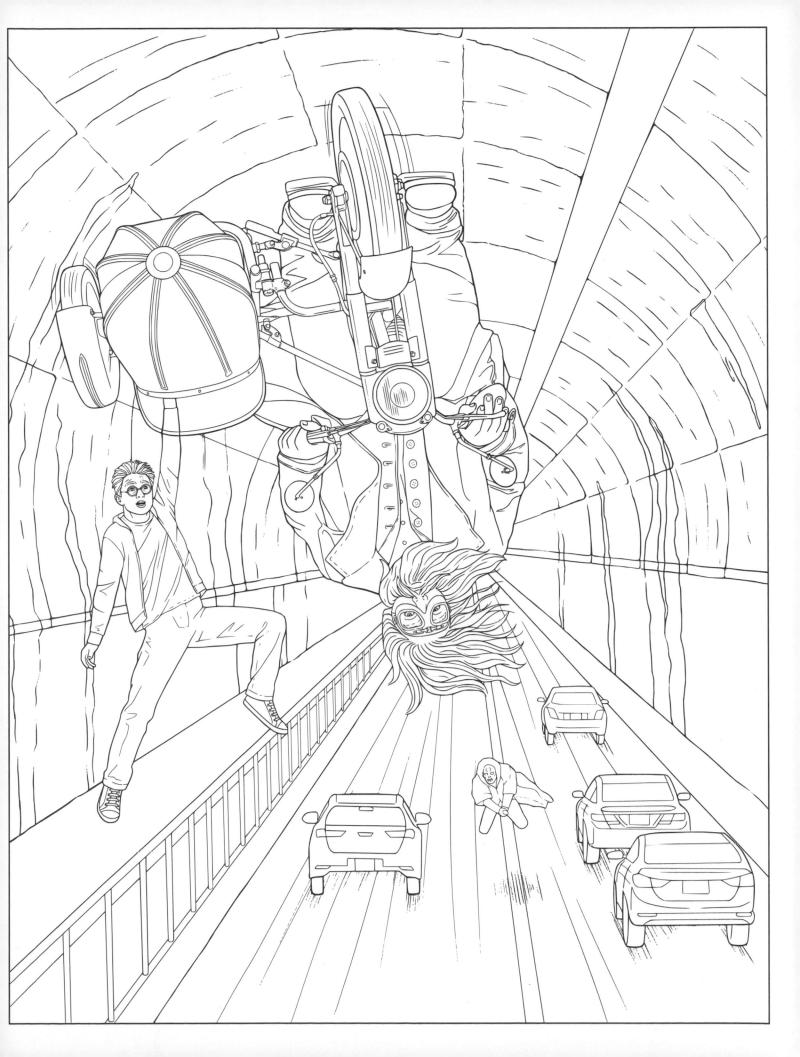

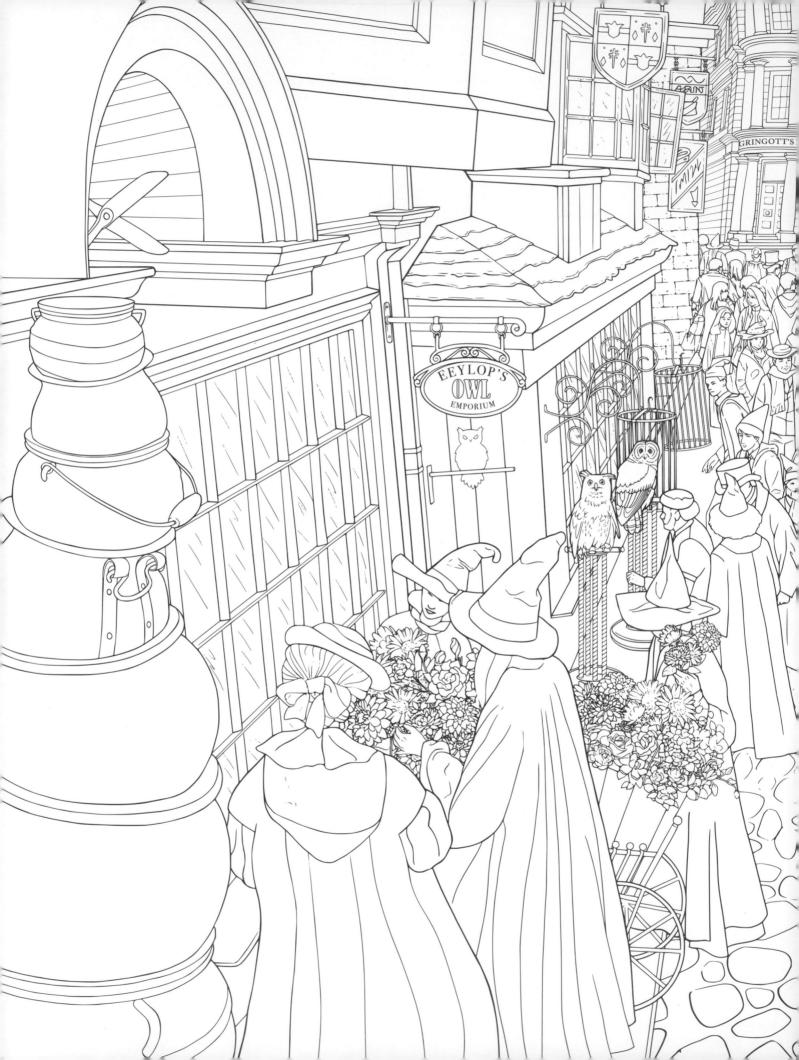

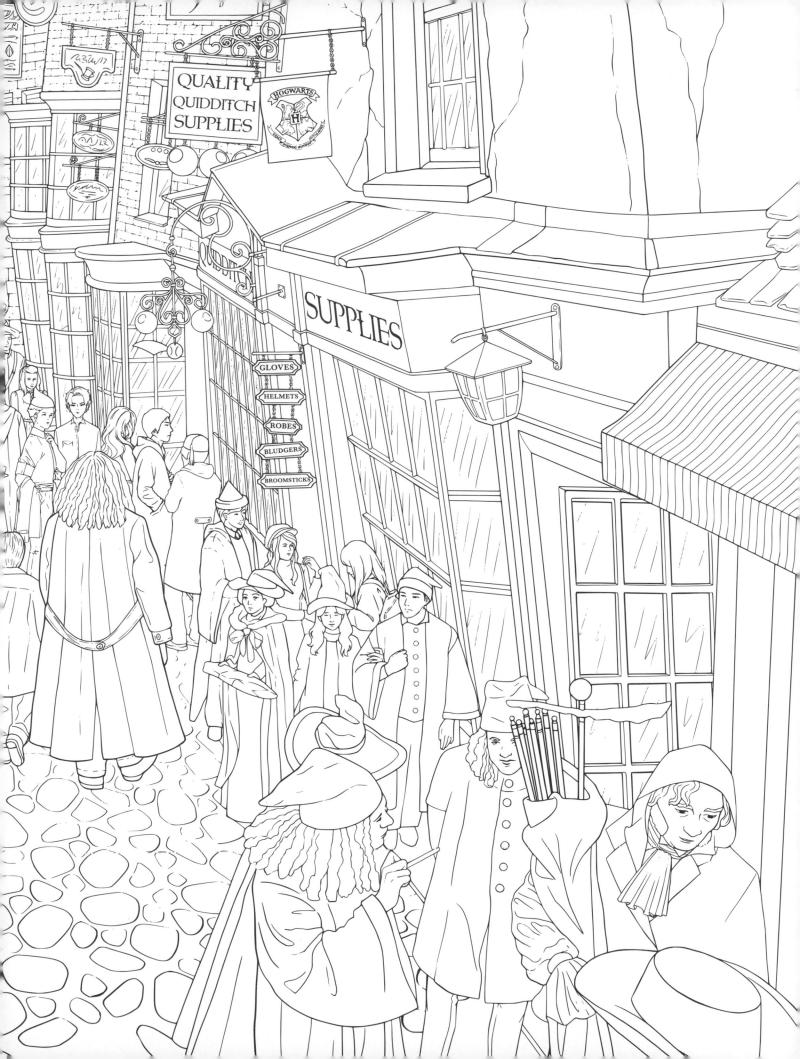

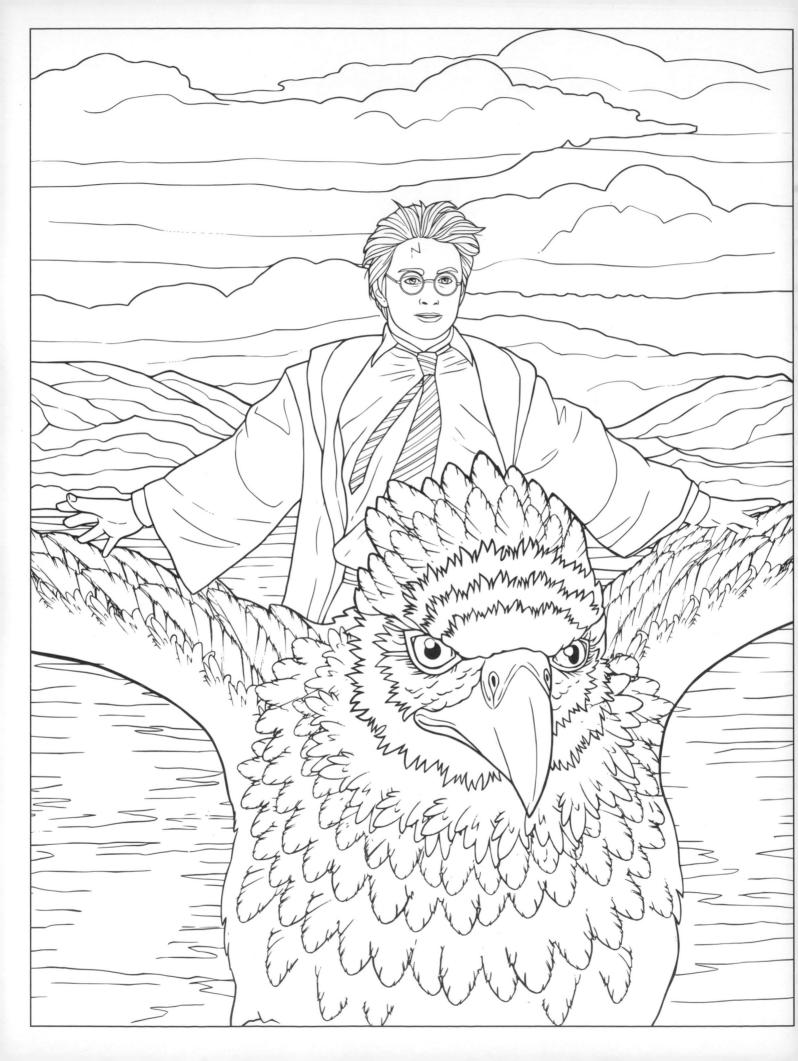

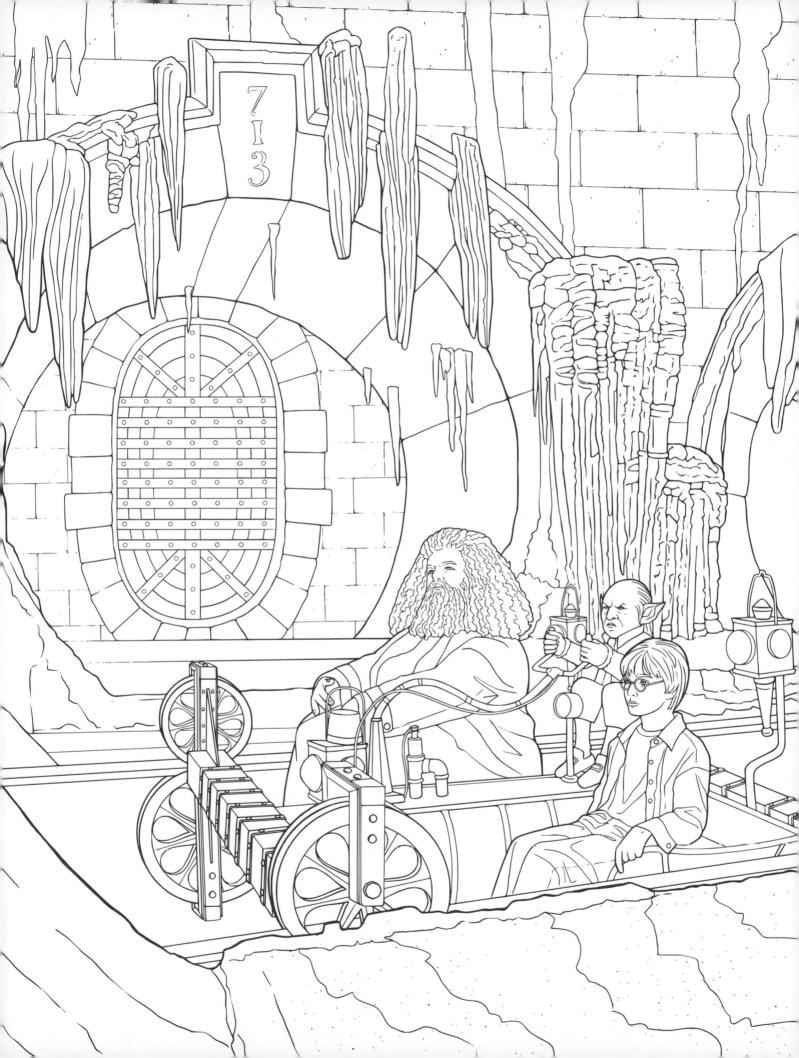

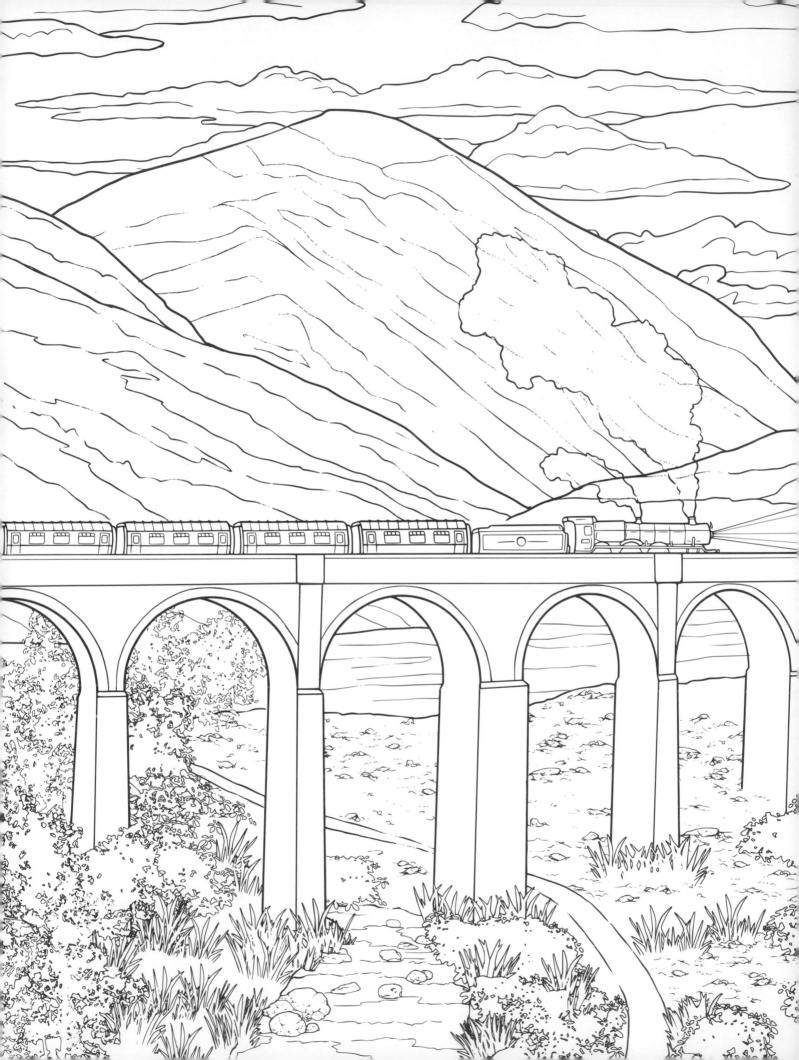

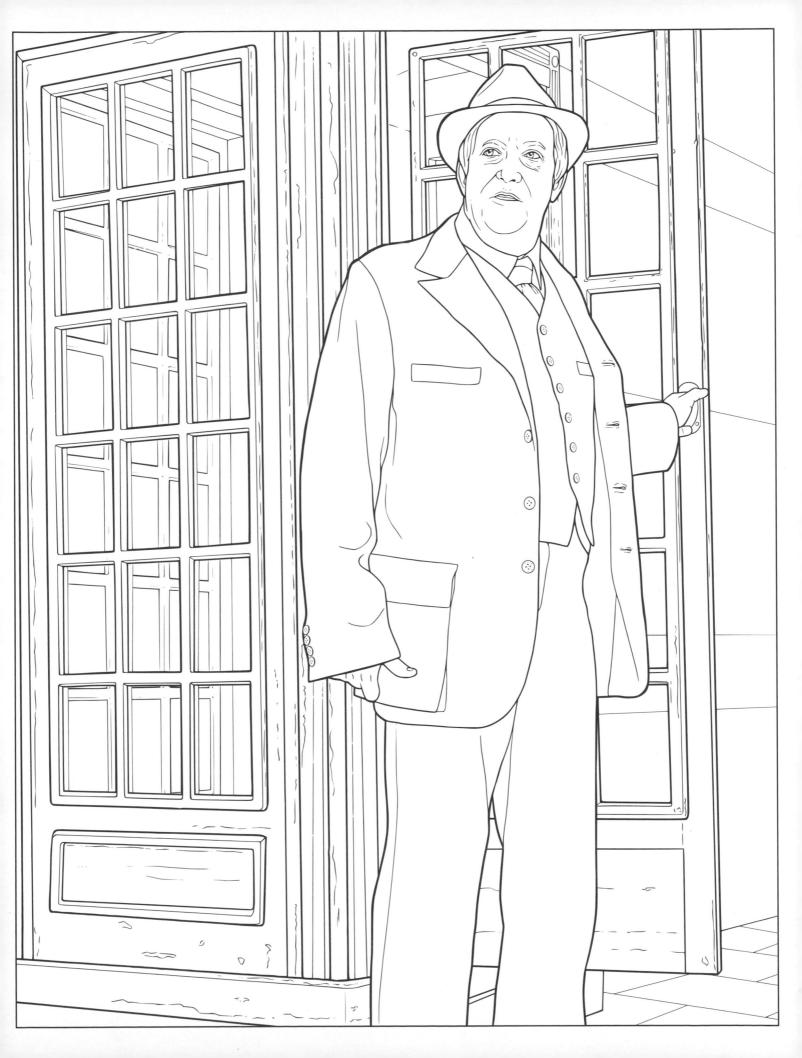

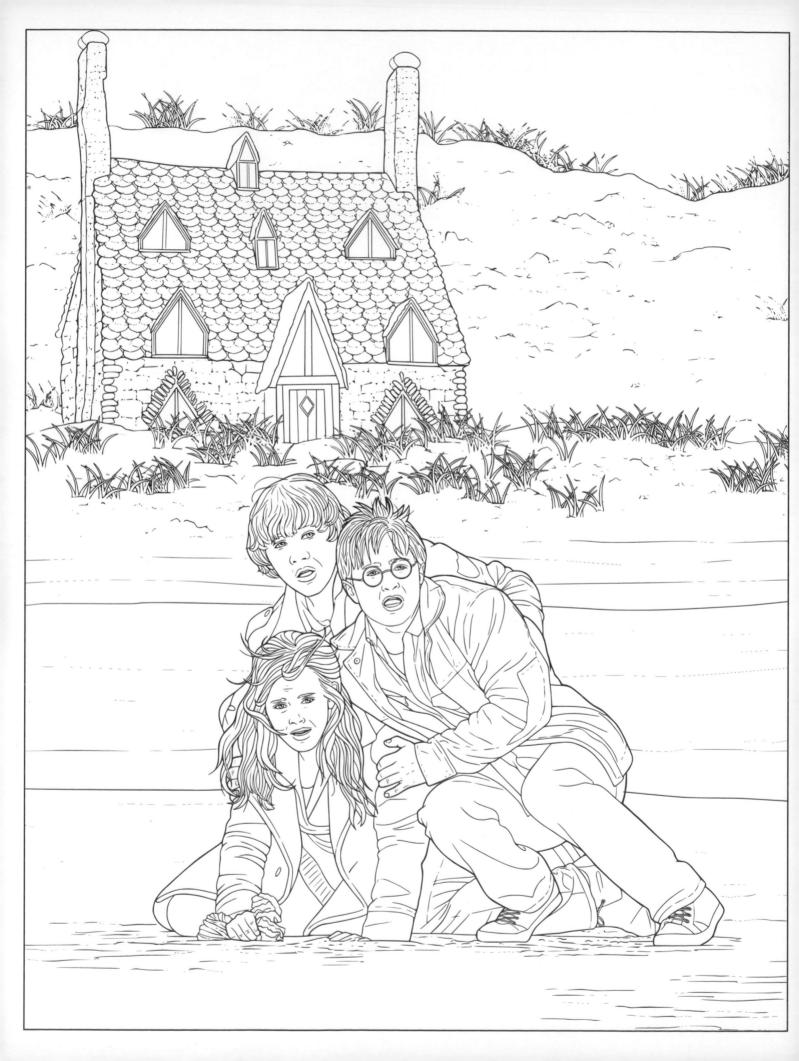

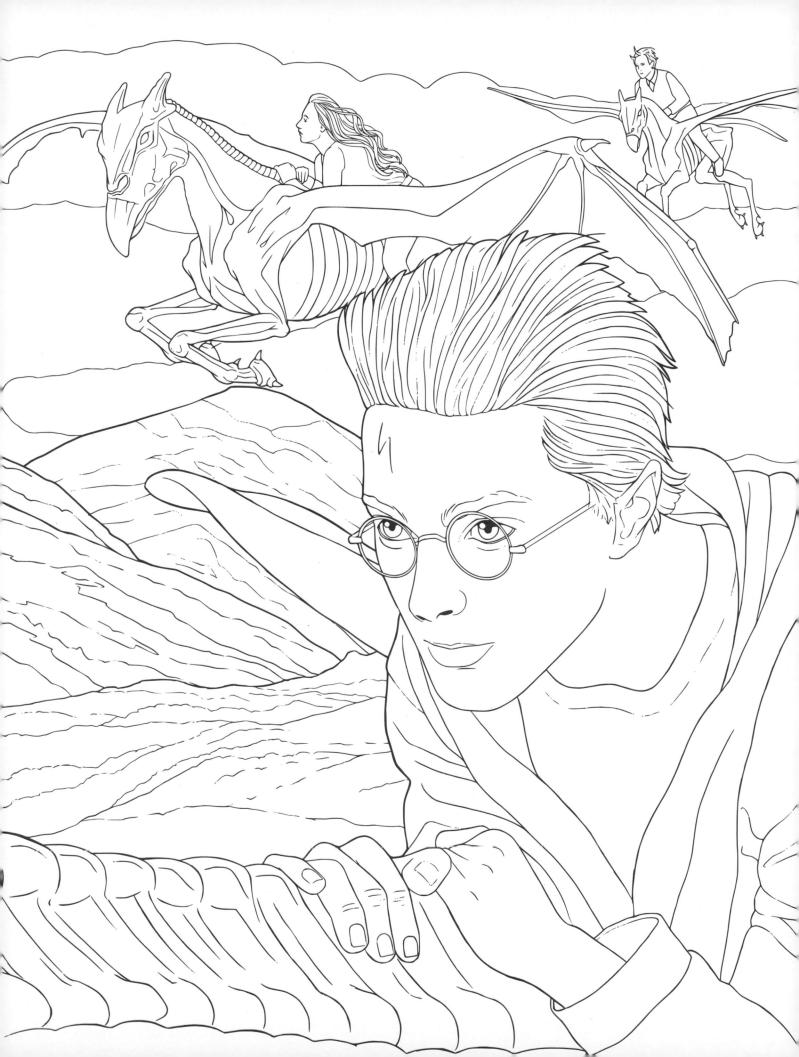

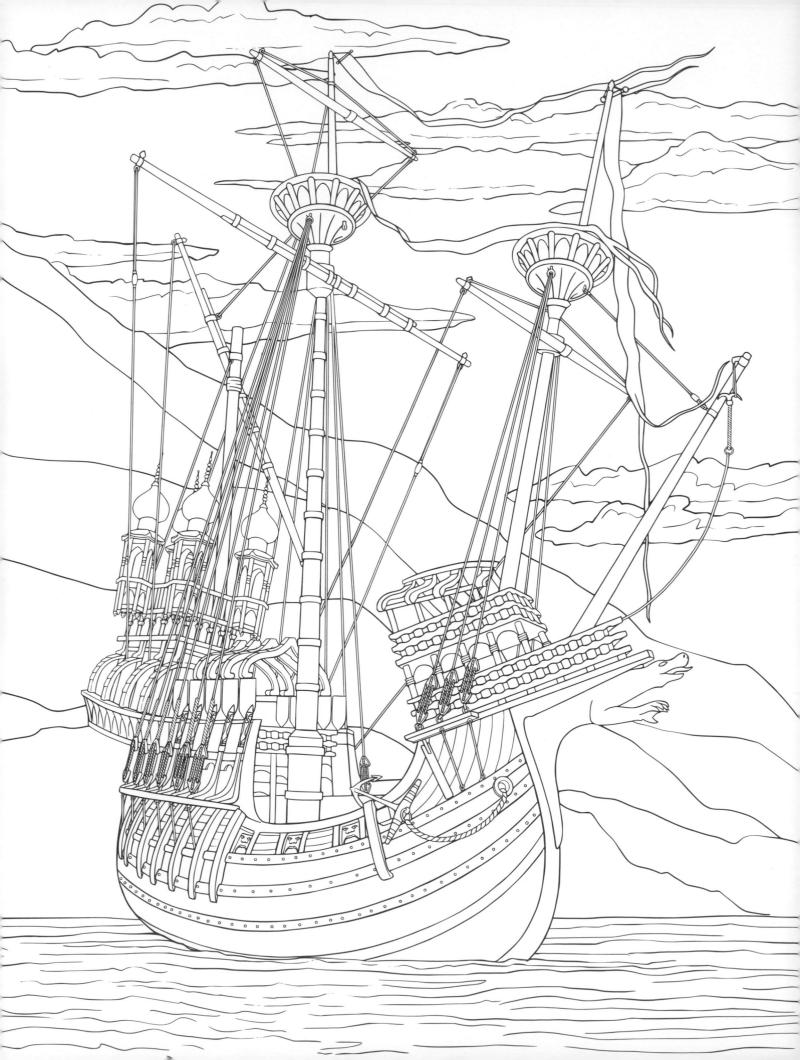

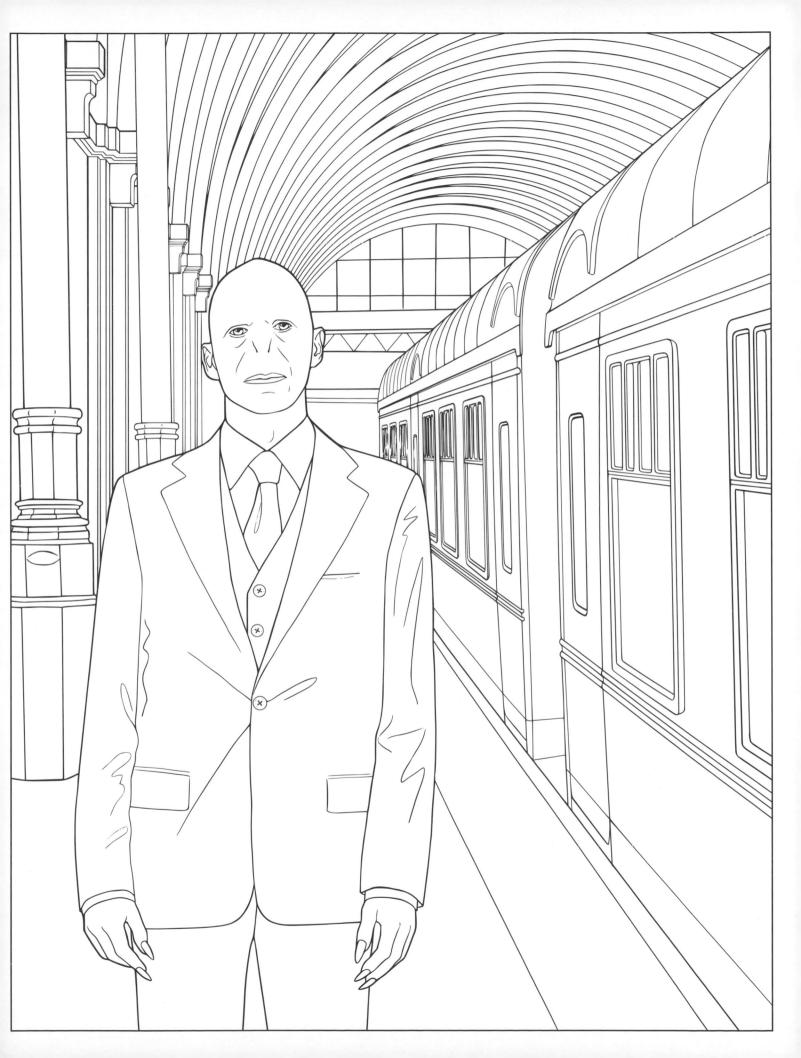

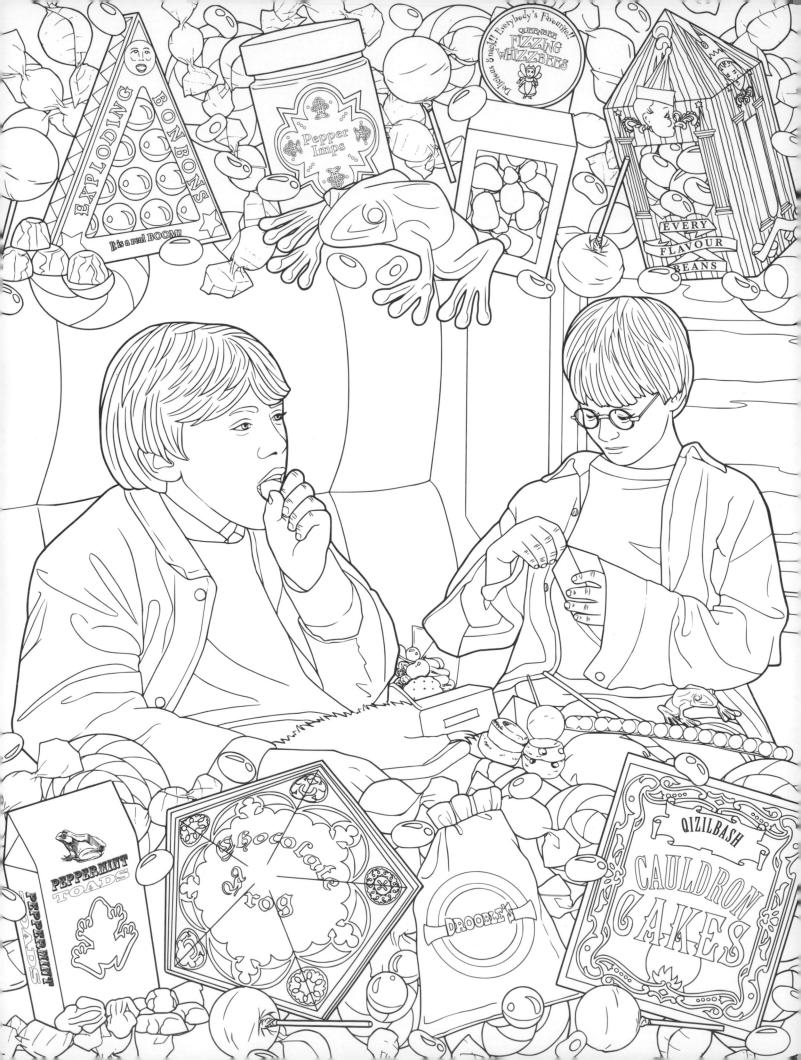

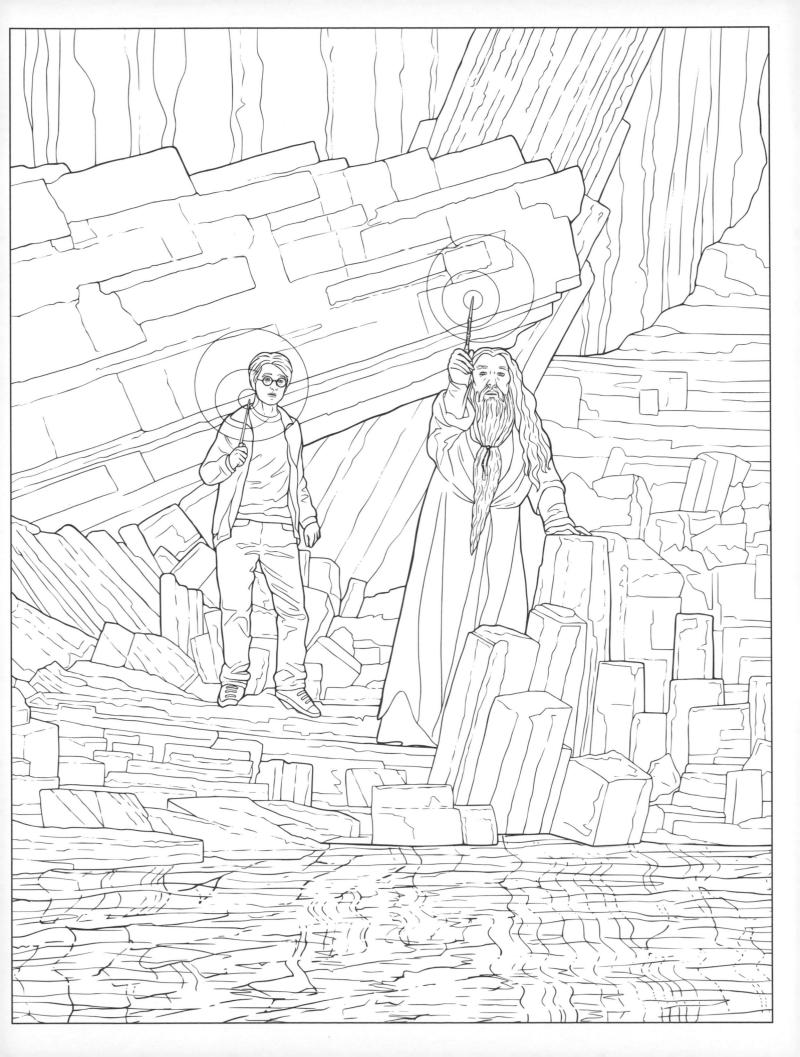

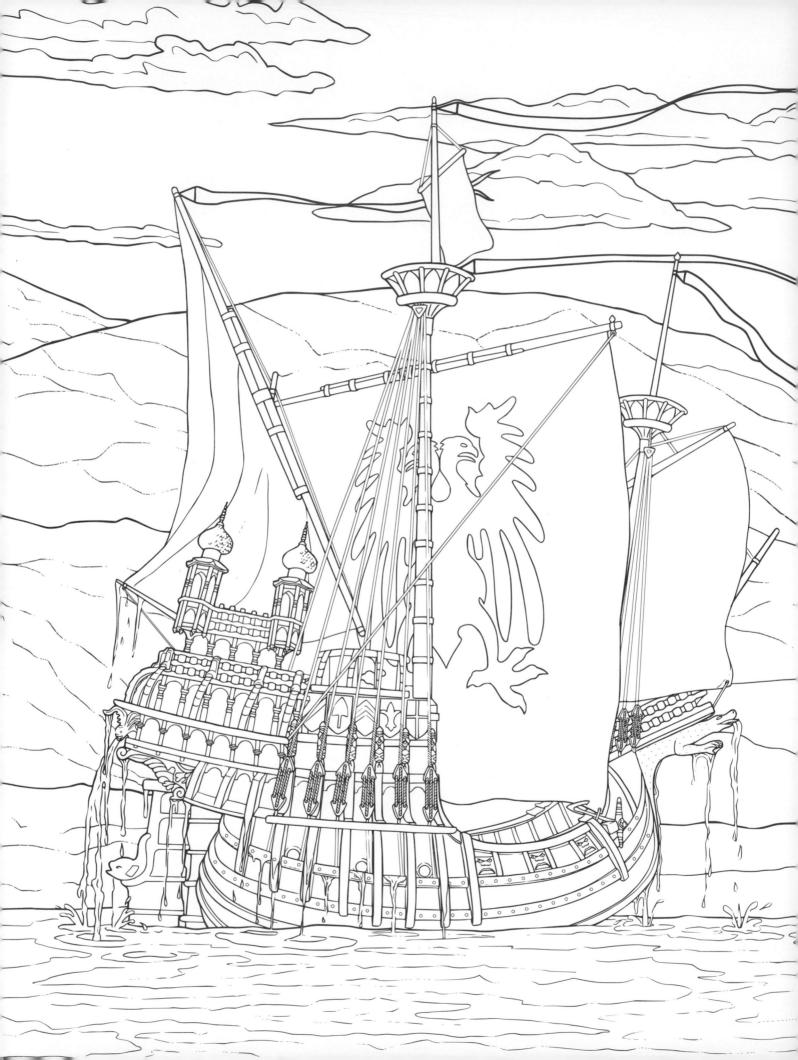

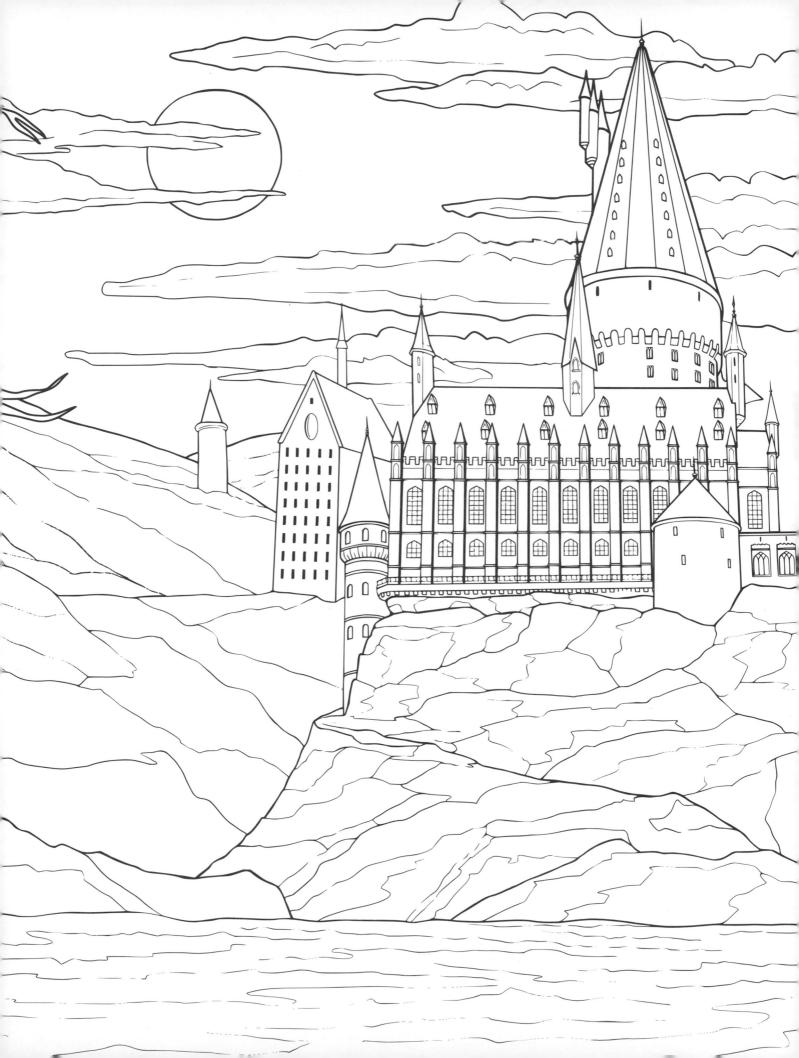

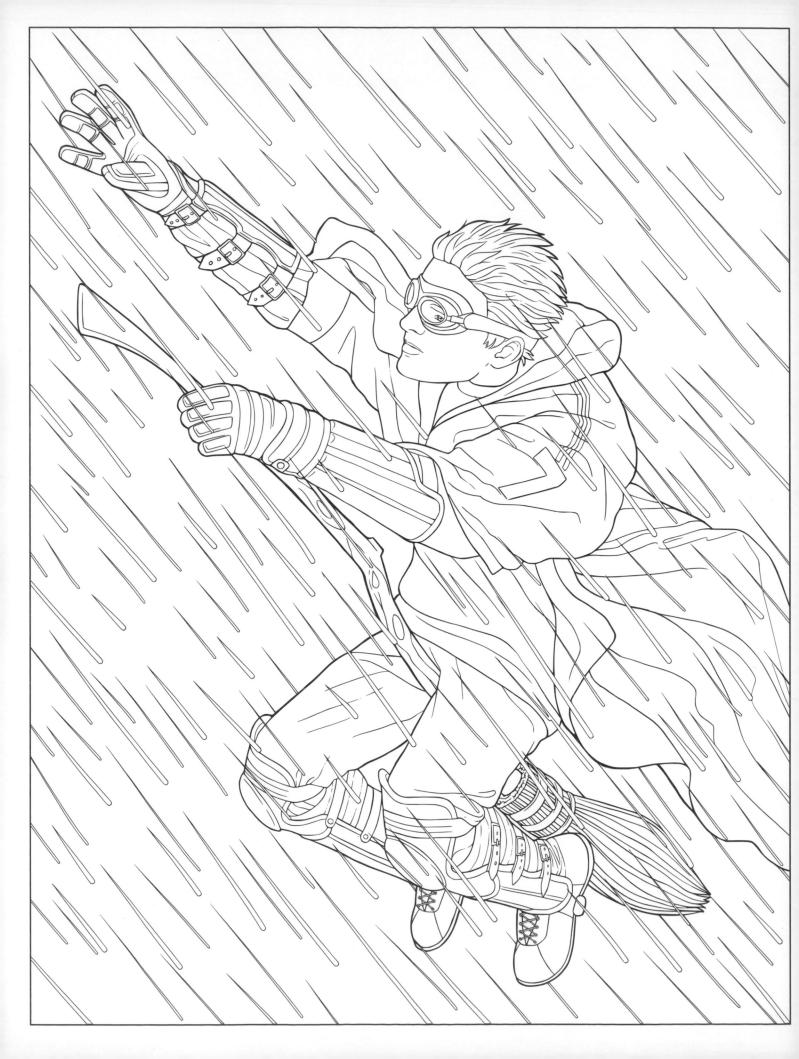

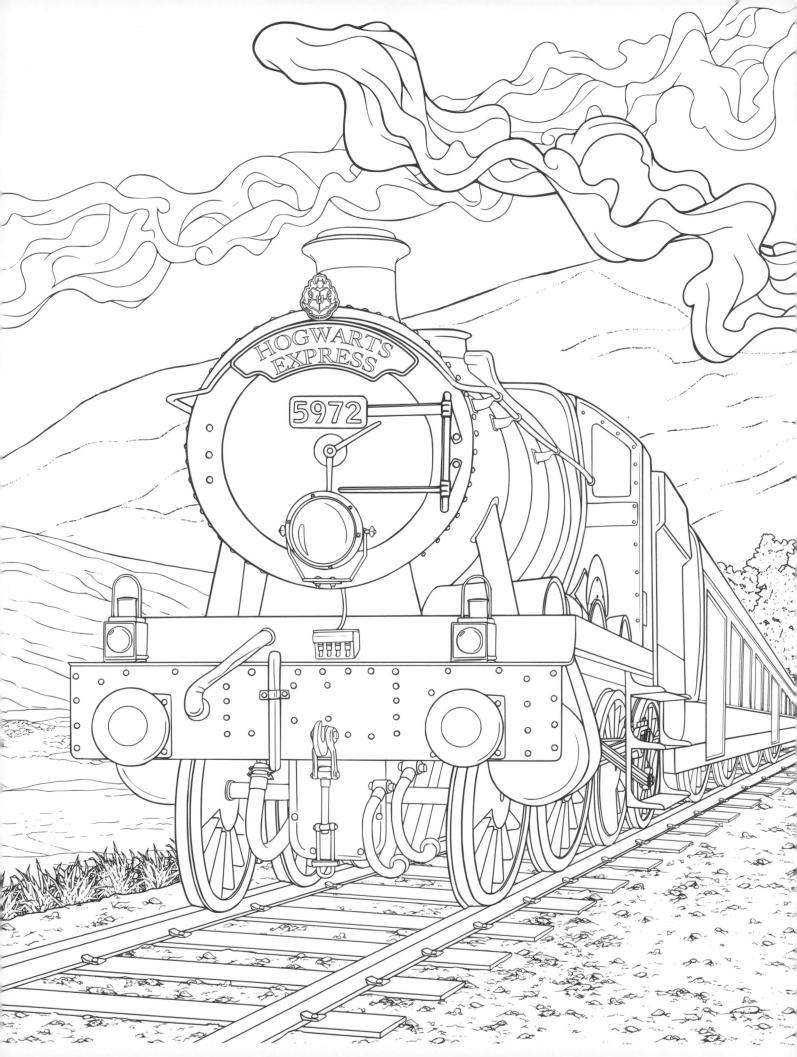

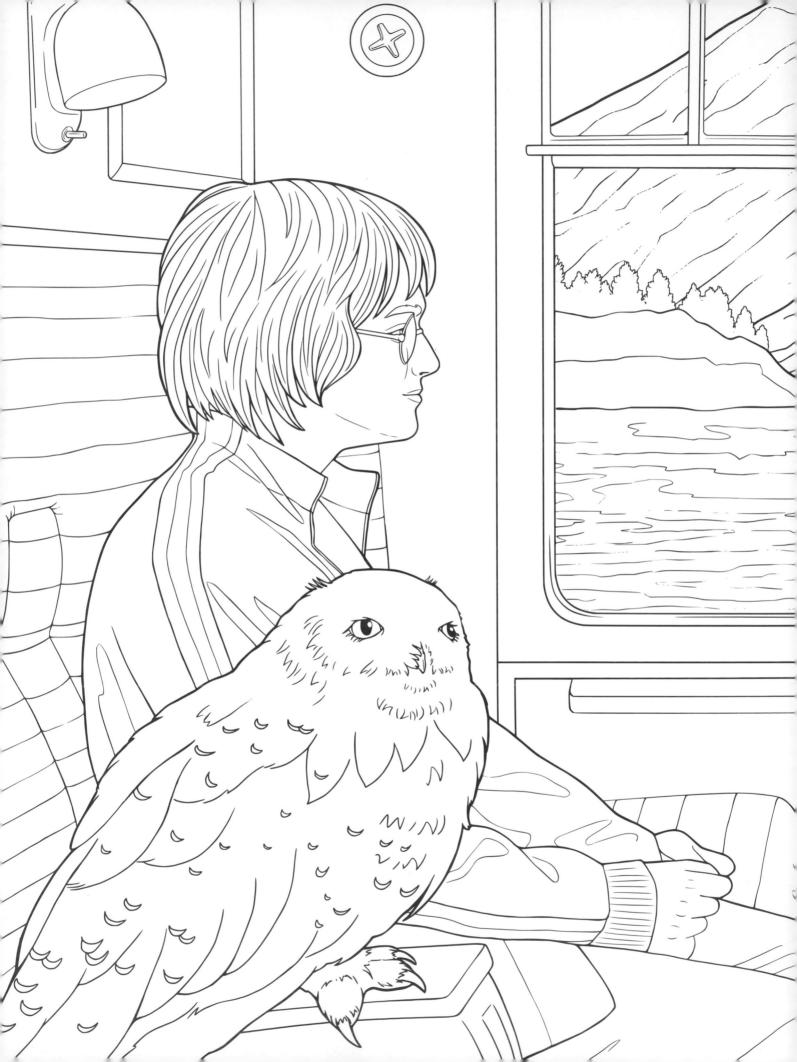

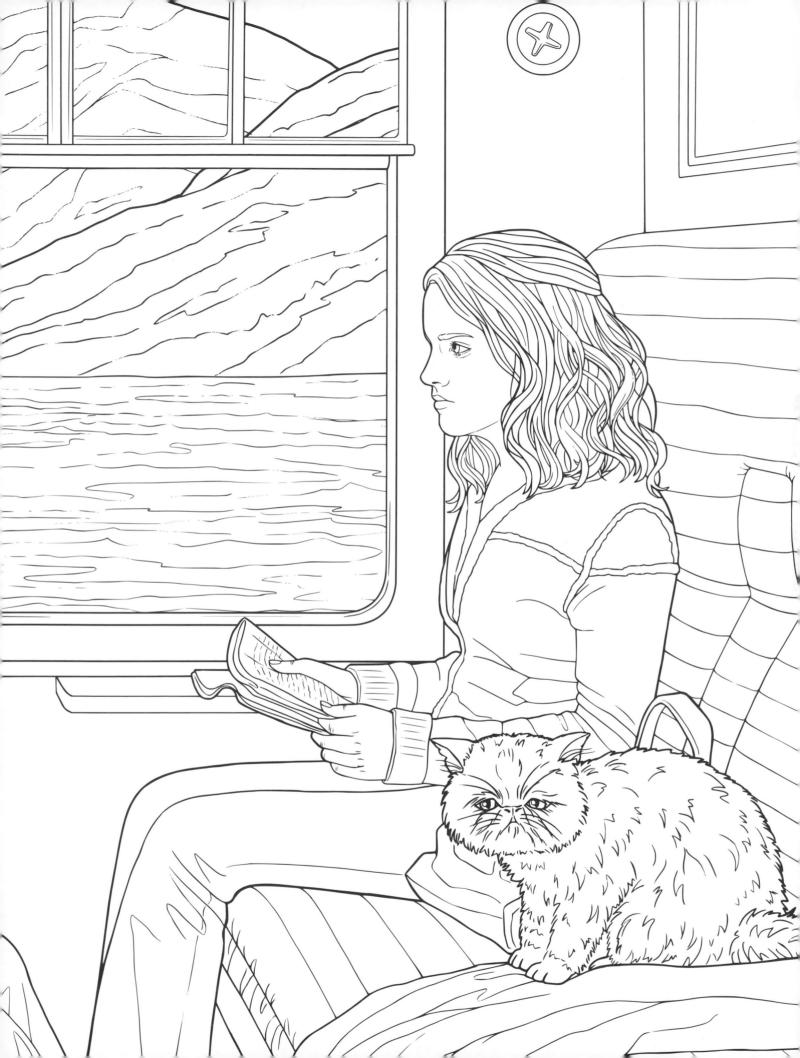

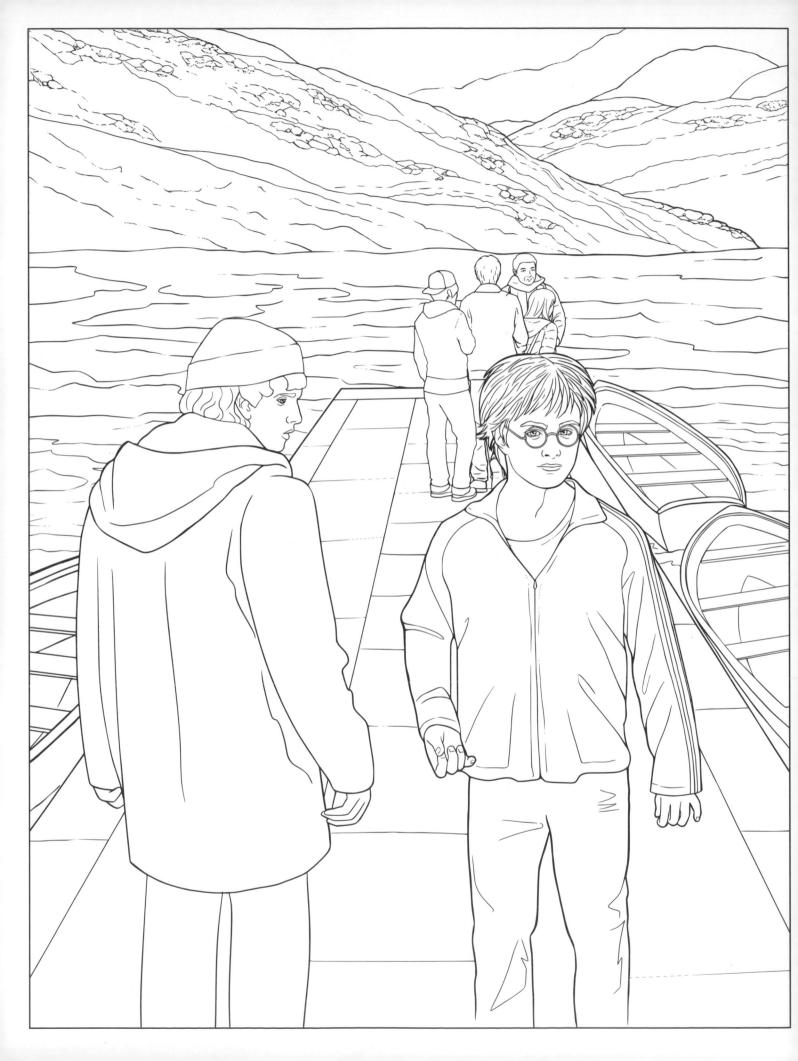

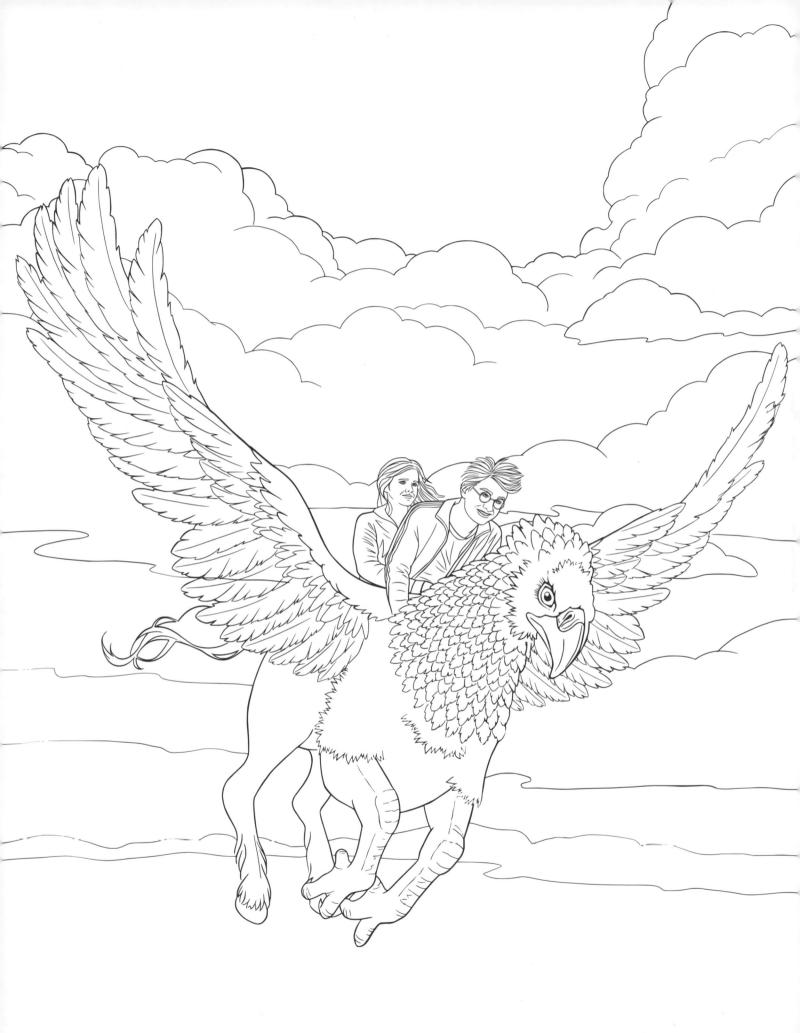

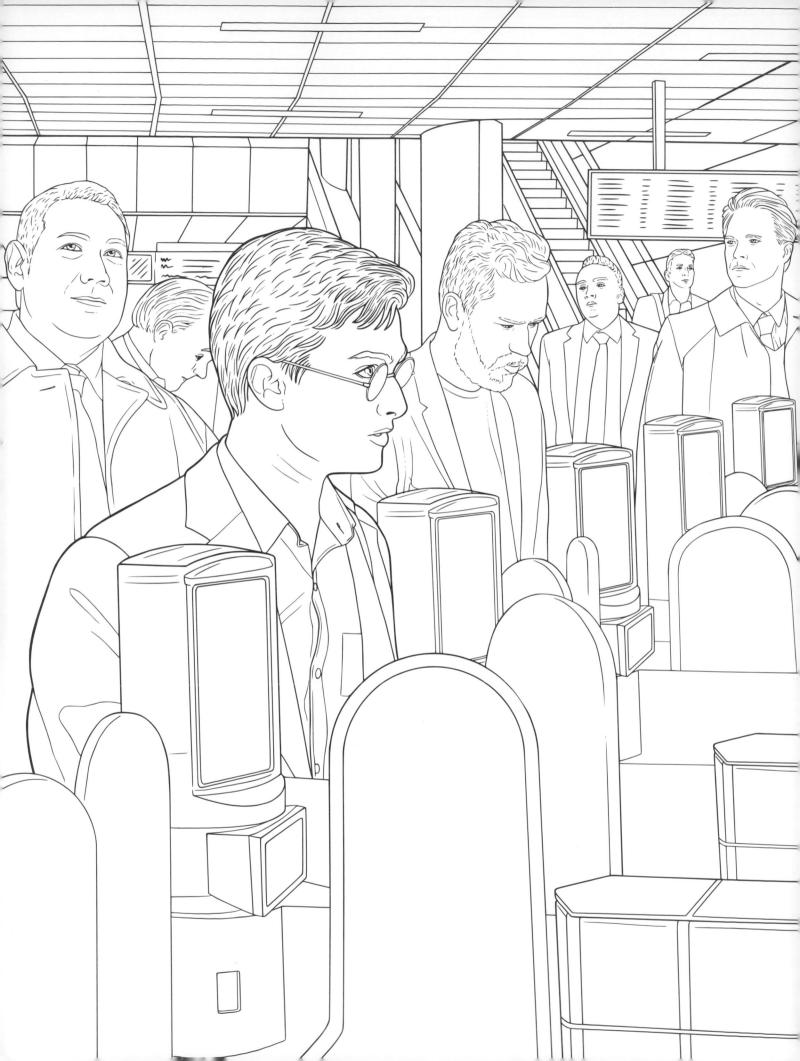

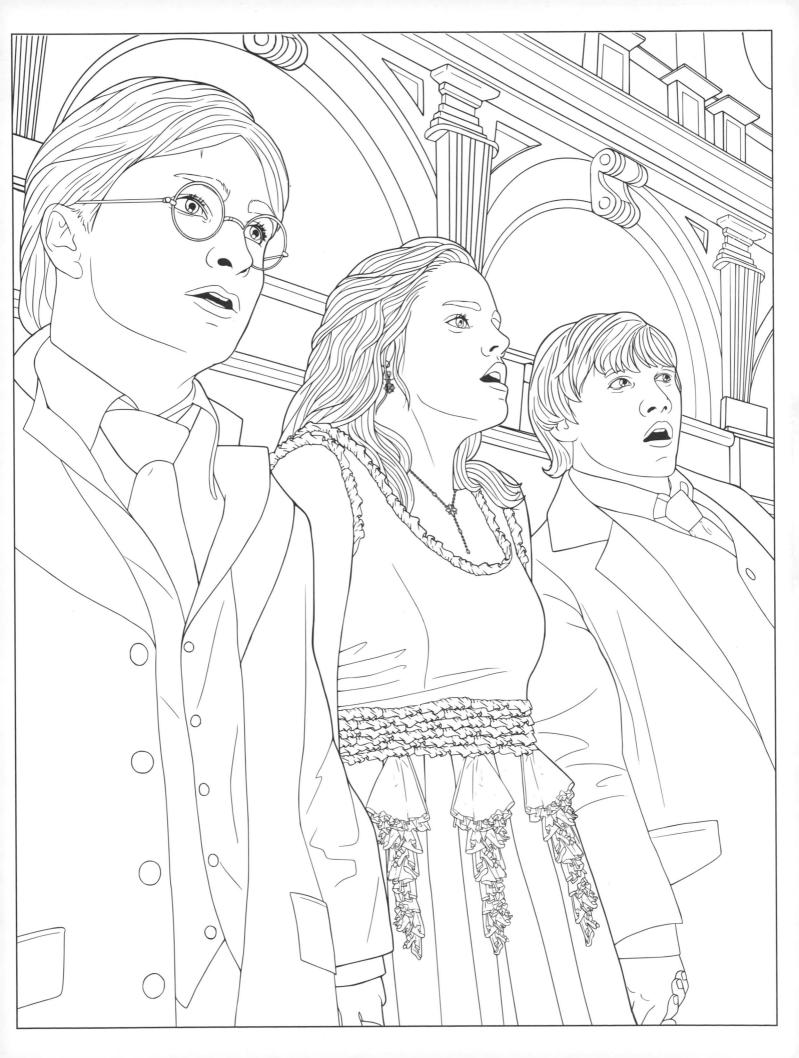

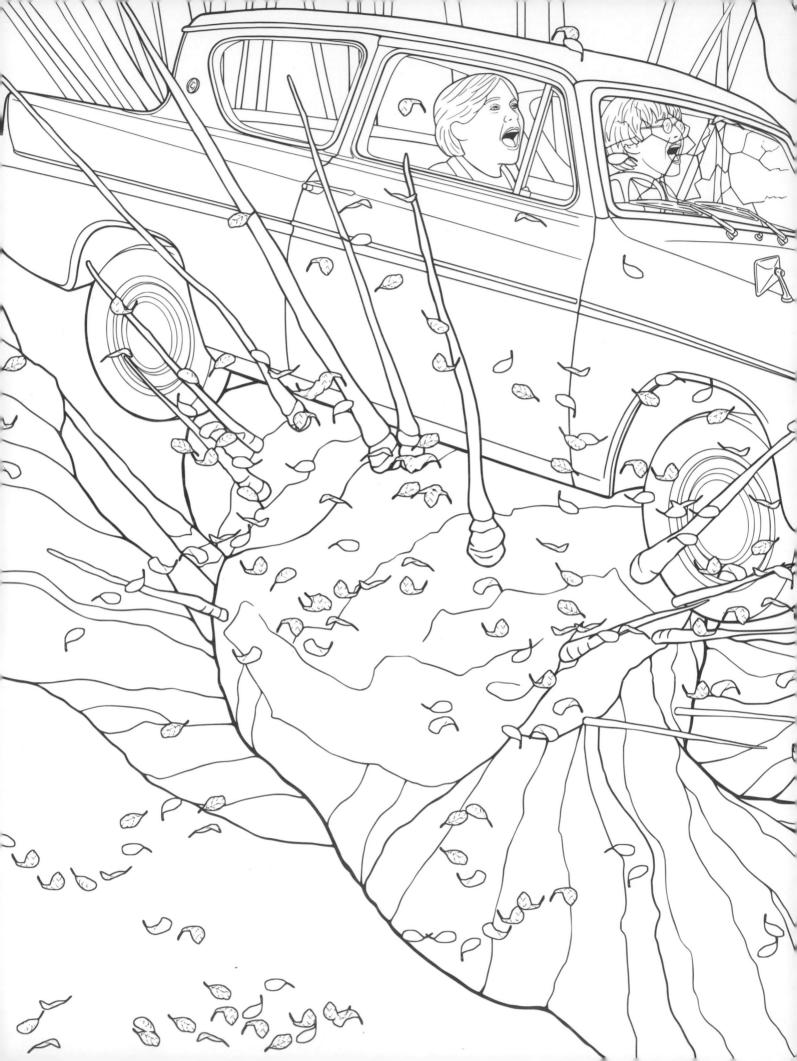

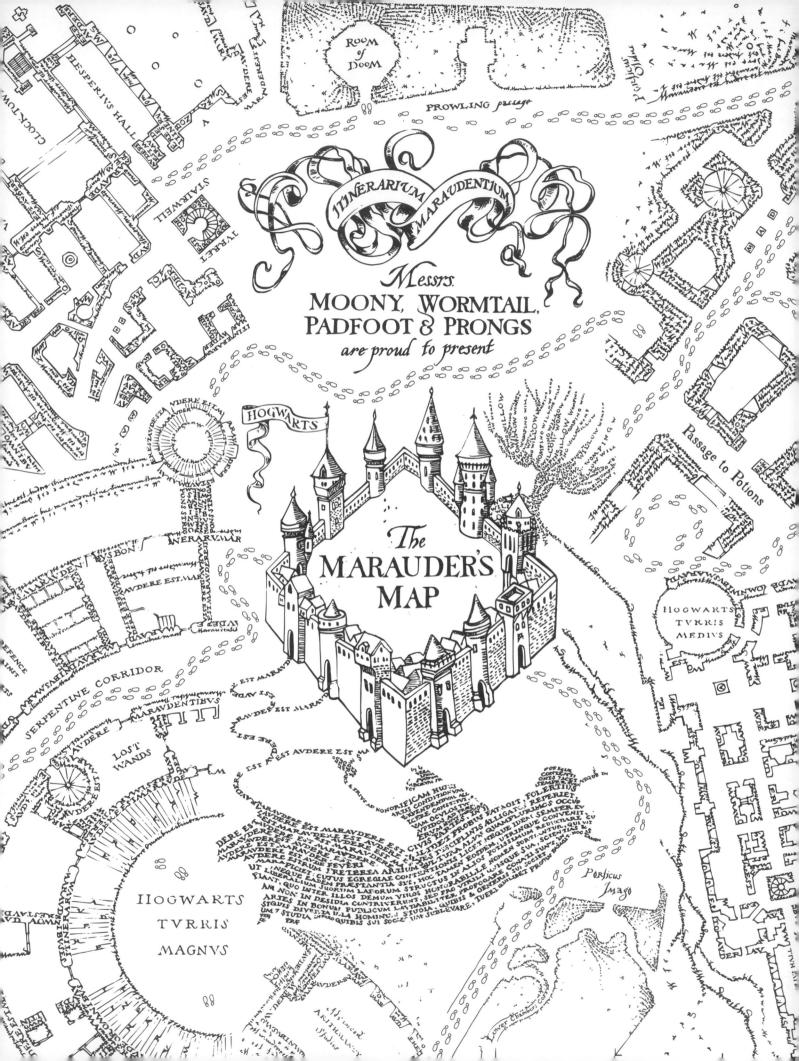

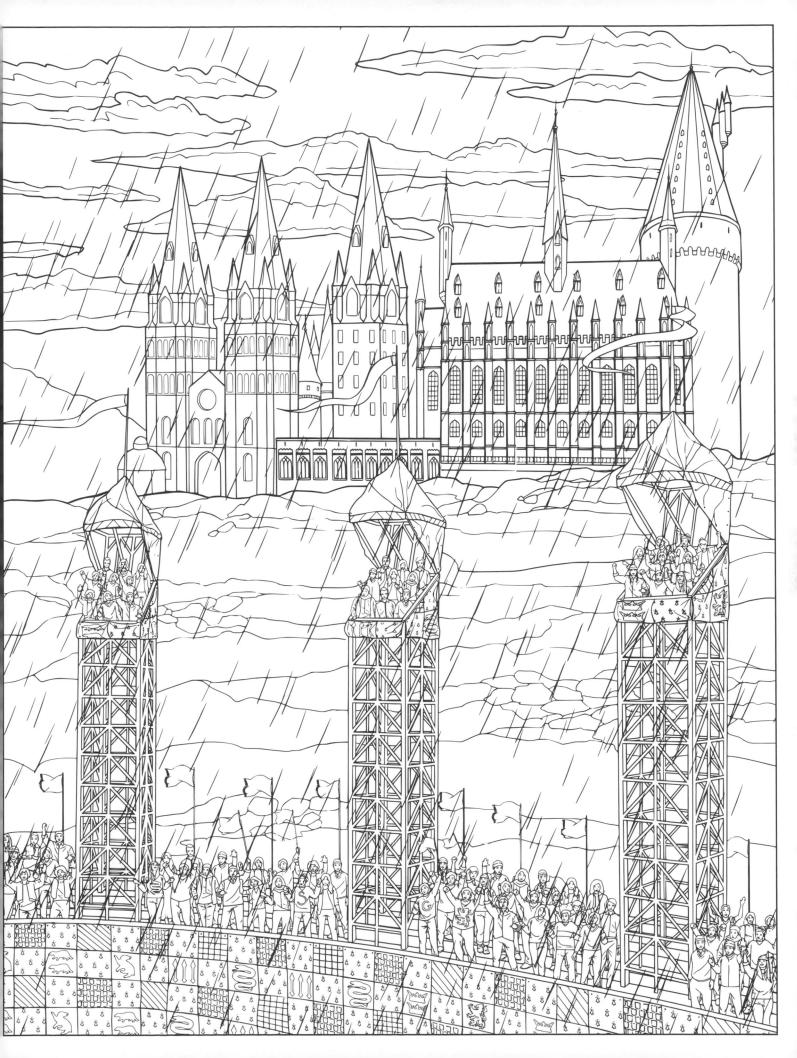

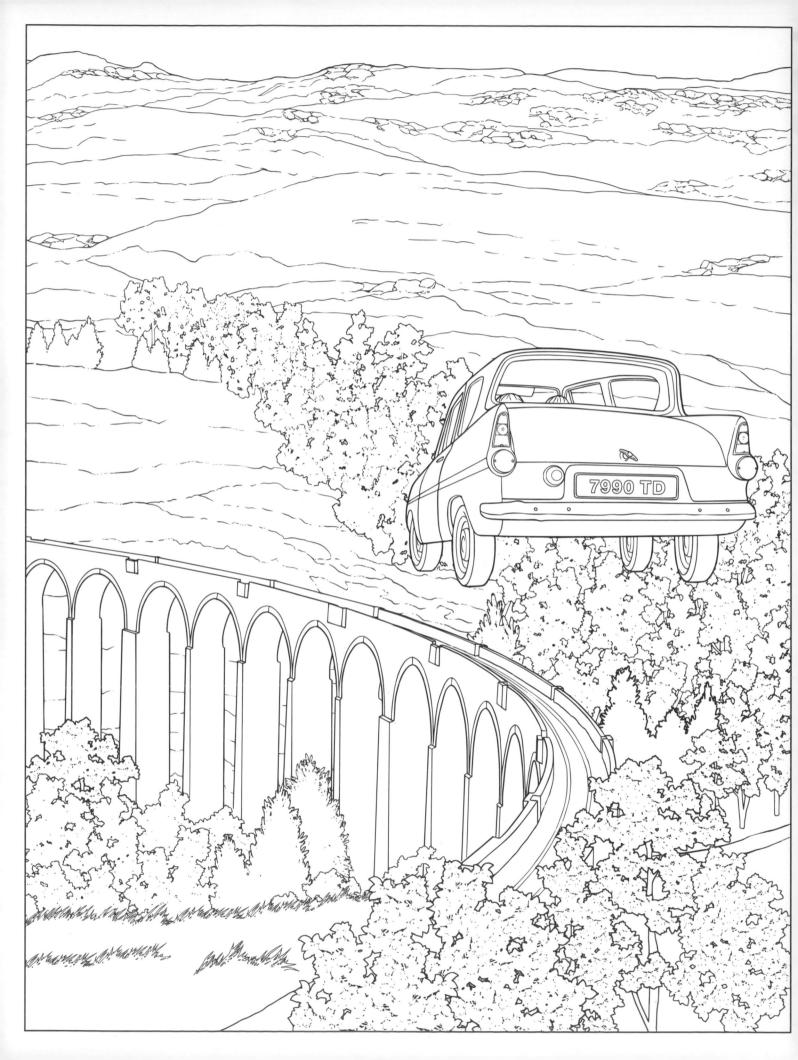

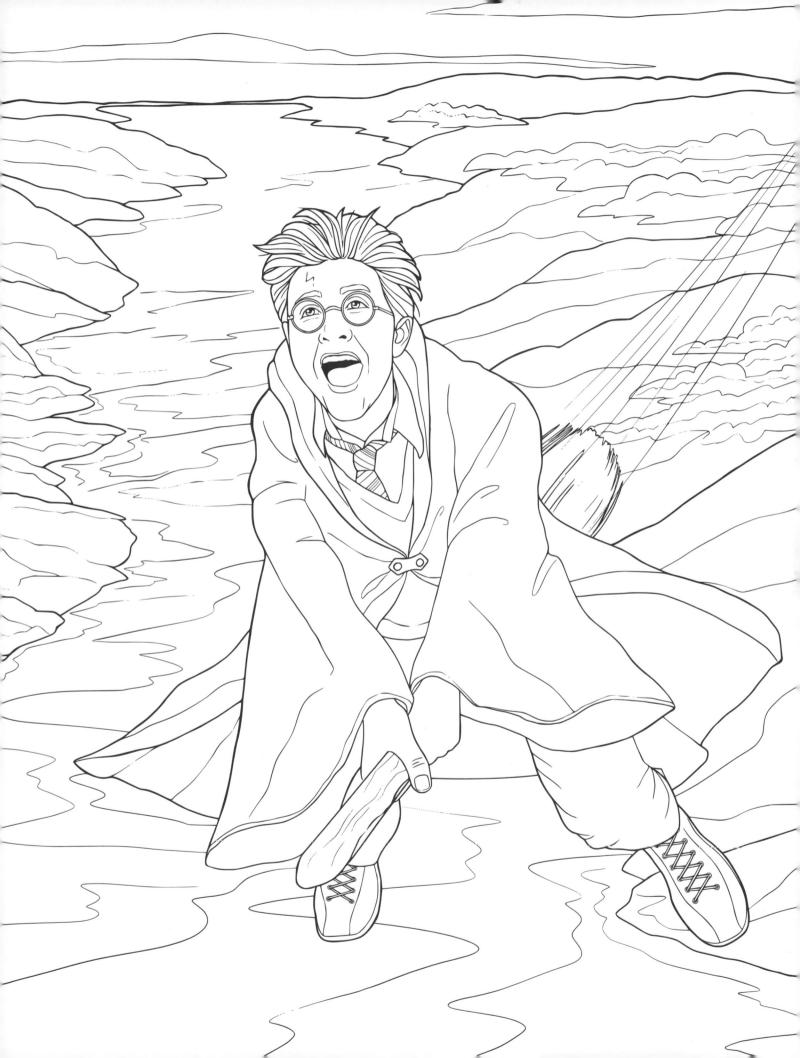

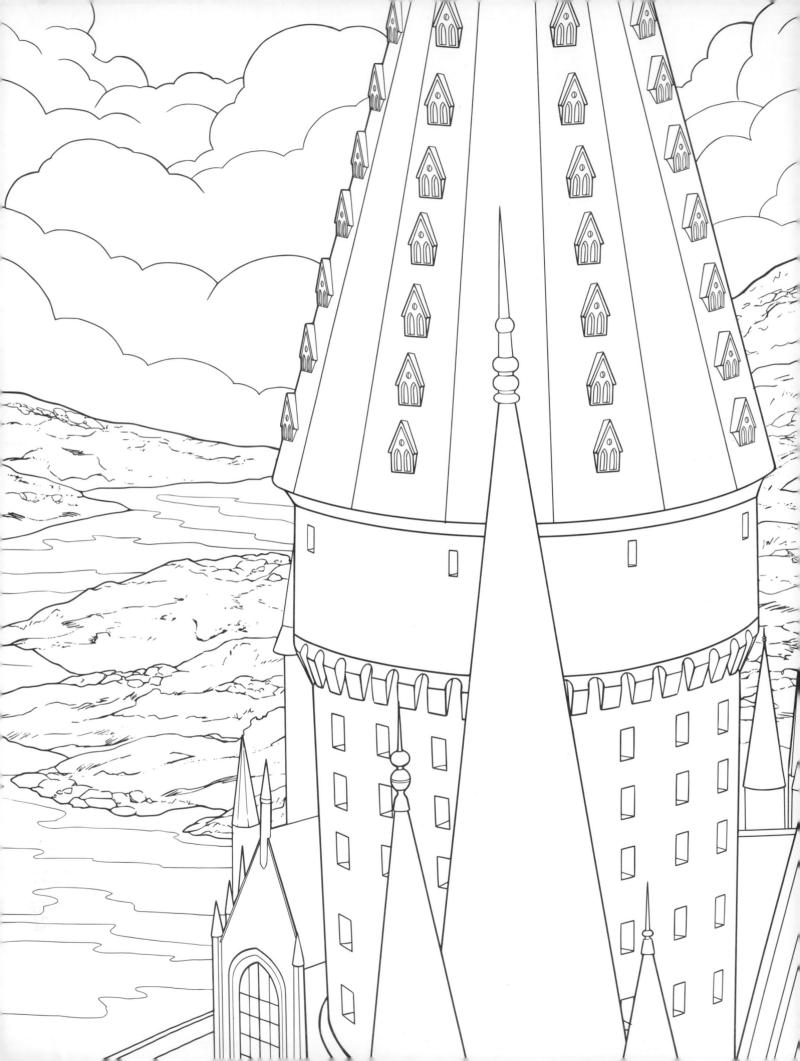